DESIGN VISUALIZATION

EXPLORING EXPRESSIVE VISUALIZATION THROUGH ART FUNDAMENTALS

DESIGN
VISUALIZATION

EXPLORING EXPRESSIVE VISUALIZATION THROUGH ART FUNDAMENTALS

FOR ARCHITECTS, LANDSCAPE ARCHITECTS, URBAN DESIGNERS, AND INTERIOR DESIGNERS

BY
SHIMA RABIEE
FINE ARTIST, CREATIVE DESIGNER

ORO
EDITIONS

Publishers of Architecture, Art, and Design
Gordon Goff: Publisher

www.oroeditions.com
info@oroeditions.com

Published by ORO Editions

Graphic Design: Shima Rabiee
Text: Shima Rabiee
Project Coordinator: Kirby Anderson

10 9 8 7 6 5 4 3 2 1 First Edition

Library of Congress data available upon request. World Rights: Available

ISBN: 978-1-941806-03-6

Color Separations and Printing: ORO Group Ltd.
Printed in China.

International Distribution: www.oroeditions.com/distribution

ORO Editions makes a continuous effort to minimize the overall carbon footprint of its publications. As part of this goal, ORO Editions, in association with Global ReLeaf, arranges to plant trees to replace those used in the manufacturing of the paper produced for its books. Global ReLeaf is an international campaign run by American Forests, one of the world's oldest nonprofit conservation organizations. Global ReLeaf is American Forests' education and action program that helps individuals, organizations, agencies, and corporations improve the local and global environment by planting and caring for trees.

*To my husband for believing, encouraging,
and supporting me in this journey.*

CONTENT

ENDORSEMENT

"This is the book the creative realm has been anticipating! *Design Visualization* follows in the footsteps of Mendelowitz's classic text *A Guide to Drawing*, and breaks new ground by illustrating an inventive methodology for merging hand drawing with digital techniques. The author uses examples of master art works as a foundation for creating contemporary digital masterpieces of environmental communication. Key to this text is the discussion of methods which will help readers integrate classical artistic principles of visual composition into their own creative process.

"The author is an accomplished fine artist, practitioner, architect and landscape architect who has been able to bring these diverse artistic arenas together into a new form of artful presentment. Ms. Rabiee has developed a clear step-by step system that combines hand and digital tools to inspire the reader to develop his/her own individual style of presentation and elevate it to an art form.

"*Design Visualization* proposes cinematographic techniques to dramatize space and render form through color theory, lighting, texture, and spatial composition to enliven and enrich a designer's vision. Regardless of the reader's skill level, *Design Visualization: Exploring Visualization Through Art Fundamentals* will be useful for many years to come."

Chip Sullivan, ASLA,
Professor, University of California, Berkeley
Author of *Cartooning the Landscape*

"I have been hand drawing since the age of eight, and I have been practicing and teaching architecture, urban design, and landscape architecture for 38 years. Shima's heart-felt, carefully narrated and crafted book helped me understand what and how I have been trying to communicate graphically. The notions are clearly depicted and organized into categories of compositional tolls, establishing analogies between the way art masters have used them and her own beautiful drawings and renderings. By doing so, she offers clues and tolls for compelling representations in project design.

She provides the reader with a great pedagogical journey, particularly at a time when computer-generated visuals, while strongly captivating viewer's emotions, frequently overlook the value of spatial definition, proportions, relations, contrasts. Her book shows how drawings and other means of graphic representation have the ability to synthesize the essence of morphological and experiential settings."

David Gouverneur, ASLA
Associate Professor of Practice, School of Design, University of Pennsylvania
Author of *Planning and Design for Future Informal Settlements: Shaping the Self-Constructed City*

"*Design Visualization* is an invaluable resource for designers of built environments. Through the lens of art fundamentals, Shima Rabiee has taken great strides to bridge the knowledge gap between visual experience and spatial representation. Drawing on her professional expertise as an artist and landscape architect, Rabiee makes ingenious analogies between historical masterworks of drawing and painting and contemporary approaches to making and representing physical space. She clearly defines the common vocabulary of design with analytical diagrams and illustrations, and outlines effective tips and practices for readers to improve their visual literacy and communication skills. With this book, Shima Rabiee has made a significant and critical contribution to the field of environmental design."

Elizabeth Boults, ASLA
Landscape Architect and Educator, University of California, Davis
Author of *Illustrated History of Landscape Design*

PREFACE

During my 12 years of study and practice at universities and firms specialized in architectural design, landscape architecture, and urbanism inside and outside the United States, I have become familiar with a variety of educational and design operations, as well as with the tastes and preferences of a number of designers. However, despite the variety of my experiences, I continually face the same set of questions and obstacles in each design studio, these challenges include:

- How to present a perspective rendering comprehensively and expressively with minimal time and costs for building a three-dimensional model of its plan?
- How to render all the orthographic drawings of design, such as the plan, cross sections and the elevations in a way that the depth and the three-dimensional sense of the space are expressed by them?
- How should color, harmony, composition, visual weight, etc. be applied at the service of better communicating the design and creating an attractive layout for its presentation?
- How to incorporate freehand drawing into contemporary digital drawings?

These questions and challenges—which were related to the principles of art, aesthetics and graphics—made me look for and reach out to a resource that is based on art principles and is specifically and effectively applicable to design studios. Since I could not find such a resource, I started researching and collecting materials which have come to form this publication.

We know as a fact that familiarity with the general principles of art (such as composition, form, color, etc.) is necessary for design studios in all stages of design, from creativity to forming, developing, and presenting the design. Nevertheless, many students in these studios lack this artistic background and are less familiar with the principles of graphics and aesthetics. This gap impacts the extent of their creativity and performance in the process of presenting and communicating their design ideas. There are undoubtedly numerous high-quality resources which introduce principles of art; however, those resources tend to reach much farther into artistic discussion that it then becomes difficult to use them for reference to the specific visualization needs of a design studio.

I particularly sensed this need while teaching different design studios, and it fueled my motivation for developing this book.

I was very fortunate to have had a solid background in visual arts before I started studying and practicing architecture and landscape architecture. I had already practiced as an artist for many years before entering university. I was closely engaged with the art community and worked professionally in drawing, painting, and sculpture.

My familiarity with art before entering the design studio helped me better pick up the discussions and form and communicate my designs with more ease and effectiveness than others. This experience made me feel the lack of knowledge in art fundamentals in studios even deeper on the one hand, and better comprehend the key and common points between art and design visualization on the other. Later, in my own design studios, I was able to address these common grounds more functionally and emphatically with my students.

After receiving my master's degree in landscape architecture from the University of Pennsylvania, I worked as a designer at different architectural, landscape architectural, and urbanist firms in New York City, Boston, San Francisco, and Houston. Parallel to my professional work, I taught design and presentation studios at the Academy of Art University. The experience of working simultaneously in academic and non-academic environments and practicing art and design at the same time, gave me a better understanding of the common points of art and visualization, which was very effective and helpful in putting this book together.

This book aims to introduce art principles to designers and provides them with a simple, fluent and effective way of communicating design by incorporating art fundamentals into visualization and representation processes. The book teaches the visualization process step-by-step analytically and illustratively, with freehand and digital techniques.

My hope is that this book will serve as a useful and effective reference and be a resource for those interested in art, design, and visualization.

ACKNOWLEDGEMENT

This book was developed in the course of many years and is the product of a long period of experience and collaboration with different individuals and at various academic and professional organizations. My thanks go to all of those who inspired, encouraged, and supported me during the formation of this book, especially the following:

- To *the School of Landscape Architecture* at *the University of Pennsylvania*, and its great program which demonstrates much appreciation for art. This program made me more consistent in my beliefs about the importance of engaging principles of visual arts in processes of creativity, development, and presentation of design. I feel very fortunate to have studied in this program.

- Special thanks to *James Corner* for his worthy and effective inspirations during the Landscape Architecture program and also for his constructive feedback and support in the early stages of this book's development.

- To *Chip Sullivan*, without whom this book would not have been realized. His constant and precious guidances and his support in the process of this book's development were very effective and driving. He taught me that failure is but a step towards success. He was an inspiring fellow and a true friend.

- To *Texas ASLA (American Society of Landscape Architects)*, *the College of Environment and Design* at *the University of Georgia*, and *the Academy of Art University* for the talks and workshops that they offered me, which were valuable opportunities for receiving feedback and developing and improving this book.

- To *ORO Editions* and their great support for publishing this book.

- To other fellows who inspired me either throughout my education or on my way towards realizing this book; fellows like *Valerio Morabito, David Gouverneur, Laurie Olin, Elizabeth Boults, Lucinda Sanders, Christopher Marcinkoski, and Zhaoming Wu.*

- My deepest and most sincere thanks go to my dear husband, *Meysam Torabi*, who stood by me and never withheld his support in every stage of my life.

- To my mother, to whom I owe all success in my life. Besides raising me and making sure that I had all the means to reach the summits of whatever field I desired, she taught me that no matter where I am, I should always truly and deeply believe in myself, and I cannot thank her enough for this special gift that she gave me.

INTRODUCTION

Artistic principles of presentation are the most influential factors in forming an observer's interpretation of a certain object. Artists use these principles to enhance the communication of their ideas to their audience. This book aims to teach and emphasize the importance of these principles to designers so that they too, like artists, can present their ideas more expressively and communicate more easily with their audience. This book intends to enhance the artistic knowledge and perceptions of designers, which will be realized through observation of the work of masters of art and analysis of the masters' presentation methods, followed by offering ways of effectively applying these methods to the visualization and representation of design ideas. The book also describes the application of these principles to visualization and rendering, providing step-by-step examples. These examples include both digital and freehand drawing techniques as well as their combinations. The book offers simple steps for the visualization, each of which is taught analytically and illustratively.

1

cha

ART ELEMENTS

AND

EXPRESSIVE DRAWINGS

CHAPTER I:

ART ELEMENTS
AND
EXPRESSIVE DRAWINGS

This chapter describes how design concepts can be presented in a simple and abstract way as to provide the most expressive and comprehensible impression. Since this section focusses on the works of masters of art and the analysis and comparison of principles and concepts used in their works, discussions of this section are generally accompanied by freehand drawings. However, this does not mean that the principles introduced in this section only apply to freehand drawings. As a number of topics in this section often refer to the subjective fundamentals, it is worth noting that these topics are also applicable to other techniques such as digital and mixed media.

Given that this study addresses designers, the discussions of the drawing will only be deep enough to fulfill the needs of design studios, and will not include the encompassing and complete drawing didactics employed in art programs. Three fundamental art elements will be explores in this chapter:

- Line
- Tone
- Form

Works of masters of art will be illustratively referred to in order to complement and support the chapter's discussion. After analyzing uses and implementations of these elements in the masters' works, their application to the presentation of design concepts will be studied, and their possible meanings and interpretations will be discussed comparatively.

LINE

ABSTRACT DRAWINGS (TYPE I)

Abstract Drawing is the best tool for communicating an idea to an audience because it comprises the framework and essence and carries all the physical and sensual characteristics of the subject/space. The *Line* is the most basic and fundamental element of abstract drawing which conveys the structure of objects or space in the simplest way. Using lines, it is possible to communicate complicated concepts in a clear and abstract way. Generally, there are two types of abstract drawing to note:

- **Abstract drawings type I: Quick and simple drawings which for the most part communicate the meaning or mood of a concept:**

These drawings are drawn concisely and quickly in order to communicate a concept or an idea. This type of drawing is complete and expressive in itself and does not require much detail or information to be added to it. In fact, its beauty and expressiveness are due to its simplicity and the absence of details in it. This simplicity contributes to the legibility of these drawings, so that they can communicate the aim and intention of the artist/designer.

In these drawings, the mood and concept of the space/object are more important than its physical properties and characteristics. Therefore, it is not necessary for them to comply with the principles of perspective. Factors which influence the communication of the mood and the understanding of the subject or the space are usually presented with more precision in these drawings. The following two images, *Figure 1-1* and *Figure 1-2,* demonstrate this type of drawing.

Figure 1-1 is by *John Flannagan,* who has demonstrated the anatomy most beautifully, completely and expressively with just a few strokes and lines. Each single one of these

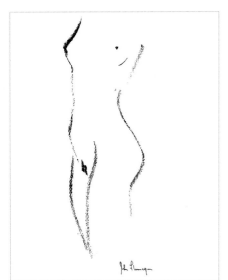

FIG 1-1. Female Nude, profile (1936). Black crayon on off-white wove paper, 16 3/8 x 11 7/8 in John B. Flannagan. Philadelphia Museum of Art, Gift of Carl Zigrosser, 1952, 1952-80-4

FIG 1-2. Abstract landscape drawing 1
Pen on paper, 8 1/2 x 11 in
Illustrated by Shima Rabiee

strokes/lines plays an important role in shaping the final mood that the viewer receives from this image. Choosing the line type and the method of drawing is also crucial in these drawings, because it plays a significant role in shaping the mood and concept that the drawn object or space delivers to the viewer. In the following pages of this chapter, we will pay more attention to the role of line movement, weight, and type. This type of abstract drawing can also be used for drawing a landscape, as you can see in *Figure 1-2*. In such sketches, the designer has to be very selective in order to communicate the essence of the concept and the visual properties of the subject to the viewer more clearly and expressively.

Look at the subsequent examples, *Figure 1-3* on this page, and *Figure 1-4* and *1-5* on the following pages, and note the following points which are the main characteristics of this type of abstract drawing:

- The main purpose of these drawings is the quick communication of the concept or mood of the space, not its physical properties or its real shape.

- The shape, weight, and movement of the line have a great impact on the mood and beauty of the drawing and on our perception of the materials, and sense of the space.

- These drawings are used for communicating the idea behind a certain concept. Therefore, despite their abstractness, they seem complete and do not require more details. Also note that these drawings, because they are not necessarily or carefully made in line with perspective principles, cannot be developed further. Therefore, they are recommended to use only at the early stages of design concept, which call for less details.

Fig 1-3. Abstract landscape drawing 2
Pen on paper, 8 1/2 x 11 in
Illustrated by Shima Rabiee

LINE

Drawing A

Drawing B

Drawing C

Drawing D

Drawing E

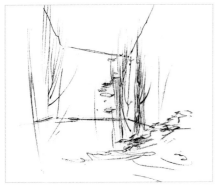

Drawing F

Drawing G

FIG 1-4. Series study of abstract drawings, type I (Drawing A to G)
Pen on paper, 5 1/2 x 8 in
Illustrated by Shima Rabiee

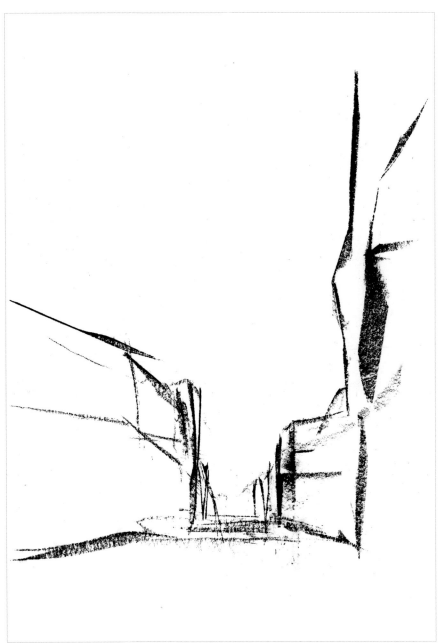

Fig 1-5. Sketch of an alley 1
Charcoal on paper, 5 1/2 x 8 1/2 in
Illustrated by Shima Rabiee

ABSTRACT DRAWINGS (TYPE II)

- **Abstract drawings type II: Precise and simple drawings which offer a real and comprehensive introduction of the object or the space:**

These are drawings which, although they appear sketchy and quick, are actually made with great precision and with respect to the dimensions, proportions, structural relations and the principles of perspective, so that they can present the real and physical properties of object/space in a comprehensive way. They can be very simple and include only a few lines which present the structure, or they can be very complex and include many details. In whatever stage, these sketches can provide a reliable introduction of the entity of the object or the space.

In these types of drawings, despite drawings type I, which were introduced in the previous section, the emphasis is mainly on the physical structure of the object or the space and not on its mood and concept. *Figure 1-6* and *1-7* exemplify the character and thinking process of these drawings. Given that these drawings are based on the perspective principles, despite the previously discussed drawings, they can be developed and lots of further details can be added to them. Therefore, it is recommended to use this type of drawing in the stage of developing and finalizing the design.

These drawings can also be easily combined with other techniques and media *(Figure 1-8)*. In chapter three, example three, freehand-digital technique, it will be explained how these simple drawings can be further developed and even mixed with digital elements in order to present a real, rendered image of the designed space.

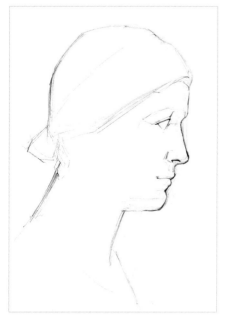

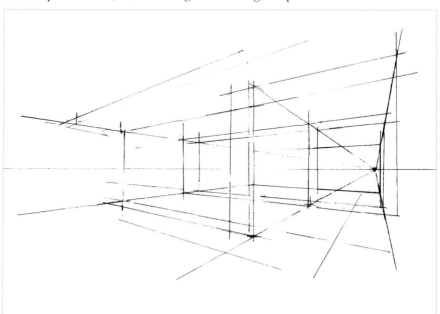

FIG 1-6. Female, profile. Pencil on paper, 11 x 17 in
Illustrated by Shima Rabiee

FIG 1-7. Abstract drawing of an interior space. Pencil on paper, 8 1/2 x 11 in
Illustrated by Shima Rabiee

Drawing A: Design concept with freehand drawing

Drawing B: Design concept with mixed media. (Collage of freehand drawing and digital element/texture)

FIG 1-8. Mixed media (Drawing A and B), 11 x 17 in
Westmoor Park, First Place National Design Competition, CT, USA
Illustrated by Shima Rabiee, Copyright to Balsley Balsley Kuhl

The following points are the main characteristics of the abstract drawing type II:

- The dimensions, proportions and relations of objects in this type of drawing are very sensitive and precise and all elements and structures follow a single set of perspective principles.

- The flow, type, and weight of lines in this type of drawing are not as important as the drawing type I, because it focuses more on the structural form and physical properties of the space rather than on its mood and dynamic.

- These drawings can be developed further, because they follow the principles of perspective, and so they can be easily mixed with and developed through other media.

ABSTRACT DRAWINGS (THE PROCESS OF CREATING ABSTRACT DRAWINGS TYPE II)

As we mentioned earlier, drawing type II should be made with great precision and based on the principles of perspective, so that we can gradually develop it, add more details to it and combine it with other media. These drawings are usually produced in one of two ways:

A. Drawing from whole to component:

This means sketching the overall picture of a space of our choice and modifying its structure based on the design concept, and then adding more details and elements to it. The following rendering, *Figure 1-9*, illustrates the process of creating mixed media rendering from whole to component.

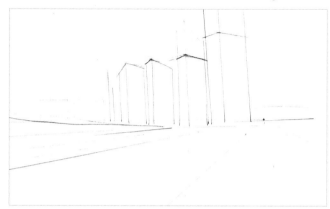

Step 1: Drawing the overall picture of a space

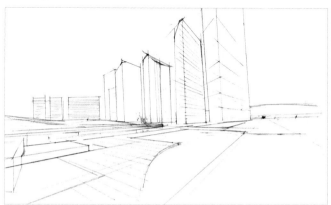

Step 2: Modifying the structure based on the design concept and adding further details to it, following the same perspective principles

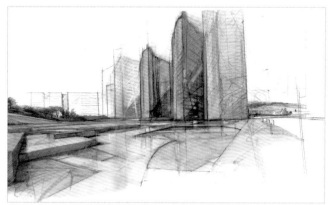

Step 3: Rendering the image with freehand media

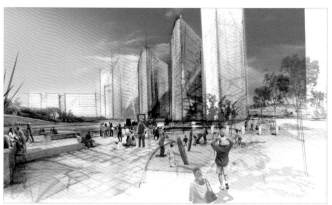

Step 4: Enhancing the image by adding digital components, materials, and texture

FIG 1-9. The process of creating a rendering from *whole to component*, (Step 1-4). Collage of freehand drawing sketch and digital media, 11 x 17 in Operation Chamartin, Madrid, Spain. Illustrated by Shima Rabiee

B. Drawing from component to whole:

This means sketching a small element or component that we would like to include in our concept, and then gradually adding the surrounding objects and context to it based on the design concept. Of course, this development of the drawing should comply with the perspective principles of the element we started with—namely with its angle, horizon line, and vanishing points—so that the resulting context and space becomes homogenous. The following example, *Figure 1-10,* demonstrates this approach. Here, the drawing began from a round seat wall which offers a friendly, cozy and interesting space for gatherings, and from that point, the design gradually evolves based on the design concept.

Step 1: Drawing a small element/design component

Step 2: Developing the surrounding context based on the design concept and with the same perspective principles

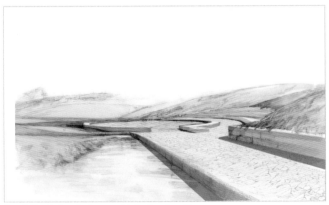

Step 3: Rendering the image with freehand media

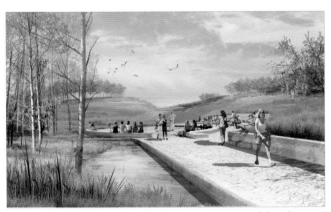

Step 4: Enhancing the image by adding digital components, materials, and texture

FIG 1-10. The process of creating a rendering from *component to whole*, (Step 1-4). Collage of freehand drawing sketch and digital media, 11 x 17 in Westmoor Park, First Place National Design Competition, CT, USA. Illustrated by Shima Rabiee, Copyright to Balsley Balsley Kuhl

A successful abstract drawing is one that, if presented in any stage, it seems complete and delivers the sense of space thoroughly. Its further development should merely be for the sake of communicating/transmitting more information to the viewer and not changing the latter's understanding and sense of the space.

- **Process of abstract drawing type II:**

To learn more about the second type of drawing, which can be mixed and incorporated with other media, let us review the stages of developing it. The following principles are prerequisite for drawing an expressive and effective sketch:

1. Mastery of principles of perspective:

Abstract drawings should be drawn precisely and based on principles of perspective, so that they can accurately present the structure, features, and dimensions of space as well as the relations of these factors to each other. A sketch that is drawn without considering these principles might merely leave a general impression of the space on the viewer, but it cannot offer a proper understanding of shapes, proportions, relations and other important features of the space. Therefore, recognizing and mastering principles of perspective—be it in the concept phase or in the final phases of drawing—is indispensable. In this stage, we draw the horizon line (HL) and the vanishing points (VP) and begin the drawing with full comprehension of perspective principals and a thorough understanding of the position of the viewer in space *(Figure 1-11)*.

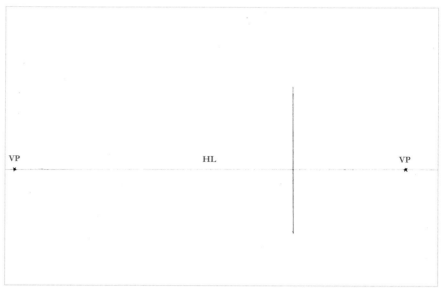

FIG 1-11. The process of abstract drawing, step one.
Pencil on paper, 8 1/2 x 11 in

2. Comprehensive understanding of the three-dimensional form and structure of all existing elements in space, as well as recognizing compositions of and relations between these elements:

One of the important and helpful strategies in abstract drawing is the three-dimensional analysis of volumes or space which helps thoroughly understand the form of each one of them as well as their compositions and relations to each other. Furthermore, this analysis allows us to identify unnecessary details and avoid them in favor of stressing the essential lines. Starting from the analysis, we can gradually eliminate unnecessary lines and include only the fundamental structures which introduce the space. The best way to do this is seeing the volumes as transparent, so that structures and relations stand out more accurately and clearly *(Figure 1-12)*.

This stage is not only effective in doing the drawing correctly, but it is also helpful in its stages of development, because it makes the position of and the distance and relation between objects in space understandable and controllable.

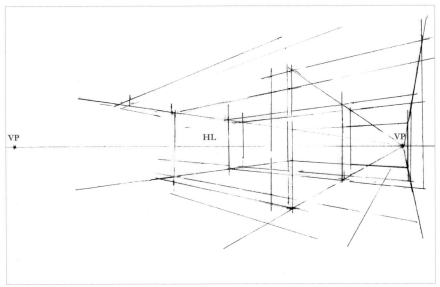

FIG **1-12.** The process of abstract drawing, step two.
Pencil on paper, 8 1/2 x 11 in
Illustrated by Shima Rabiee

3. The ability to perceive, recognize, and reveal essential lines which introduce the space and to eliminate unnecessary details:

Seeing the totality of space and nevertheless drawing simply and abstractly is, unlike its apparent easiness, a quite complicated task. Because a designer should cleverly eliminate many unnecessary details to achieve a degree of simplicity which simultaneously introduces the space thoroughly and precisely. In other words, as mentioned at the

introduction of this discussion, a successful drawing should represent the entire space and be easily comprehensible at the same time. Eliminating complexities requires a comprehensive understanding of space and mastery of principles of perspective through practice and precision in drawing and presentation *(Figure 1-13)*.

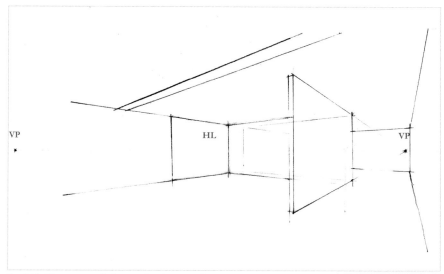

FIG 1-13. The process of abstract drawing, step three.
Pencil on paper, 8 1/2 x 11 in
Illustrated by Shima Rabiee

Note that although here we analyze abstract drawing with freehand technique, note that understanding and implementing this chapter's discussion in space is necessary and important using any visualization technique and it helps us develop the space more effectively and communicate it more clearly.

In practicing this skill, it is important to keep the following points in mind:

- In drawing the space from life, one way to actually see the space in a more simplified way is to squint instead of looking with widely-open eyes. This will automatically omit some details.

- Colors should not matter at this stage. Seeing the image in black and white, directs the attention towards the form, structure, and composition of space and not the details.

- It is recommended that this stage is practiced with pencil by beginners, because pencil offers a higher control over a variety of line weights. Then practice with pen or other tools which offer less diversity of line weights and a smaller range of playing with the line.

- Take your time to imagine or observe the entire space carefully and widely. Develop a comprehensive understanding of space before you draw it.

The following sketches, *Figure 1-14* and *1-15*, are examples of simplifying architectural spaces and representing them in abstract drawings.

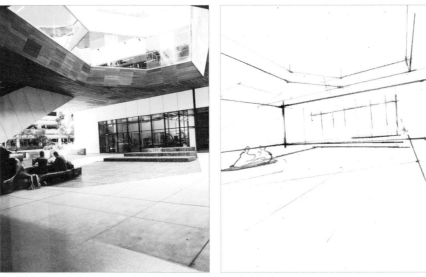

FIG 1-14. Abstract drawing (Stanford University, McMurtry Building)
Pen on paper, 5 1/2 x 8 1/2 in
Photography and illustration by Shima Rabiee

FIG 1-15. Abstract drawing (De Young Museum)
Pen on paper, 5 1/2 x 8 1/2 in
Photography and illustration by Shima Rabiee

VALUE AND THREE-DIMENSIONAL ILLUSION

Besides introducing the dimensions and physical properties of objects and the structure of space, lines can introduce other qualities as well. Controlling the pressure of the pen on paper can create different line weights and qualities which associate concepts such as depth, roughness or softness of surfaces or the three-dimensional form of objects. In the following section, each one of these concepts is introduced in simple drawings:

• **Depth:**

Line weight can indicate illusion of depth in the drawing. In order to communicate depth using line weight, objects that are further away from the viewer are presented with fainter and thinner lines, whereas closer objects are drawn with thicker and bolder lines. The following sketch, *Figure 1-16*, offers examples of this effect. Lines with different weights demonstrate the distance of trees to the viewer.

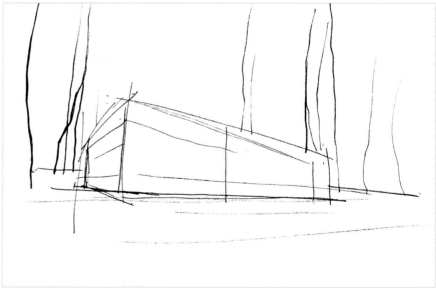

FIG 1-16. Illusion of depth in abstract drawing
Pen on paper, 5 1/2 x 8 1/2 in
Illustrated by Shima Rabiee

• **Volume:**

Line weight is also used for indicating light and shadow on the three-dimensional objects. Where the contrast between lit and shaded surfaces is greater, the lines become thicker. As an example, look at the following sketch, *Figure 1-17*. The thick line under the curved plate of the art sculpture, which is drawn based on the intensity of light and shadow, simply transforms the drawing from two-dimensional to three-dimensional and makes the volume of art sculpture stand out.

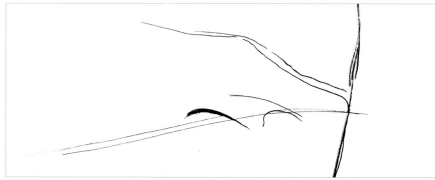

Fig 1-17. Sense of three-dimensionality in abstract drawing
Pen on paper, 5 1/2 x 8 1/2 in
Illustrated by Shima Rabiee

- **Materials and texture:**

Differing line weights sometimes express the texture or material of objects. The object's texture and its delicacy should influence the choice of line weight.

In the two following sketches, *Figure 1-18* and *Figure 1-19*, the lines demonstrate material and textural qualities by getting thinner or thicker. The sketch expresses the coarse texture of old brick structures and the wild nature of the plants with the aid of varying line weights in a simple, beautiful and abstract way.

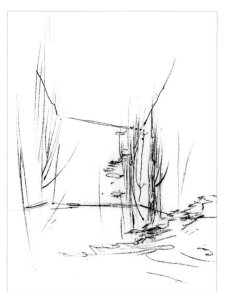

Fig 1-18. Texture in abstract drawing
Pen on paper, 5 1/2 x 8 1/2 in
Illustrated by Shima Rabiee

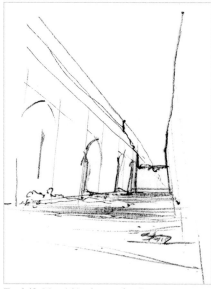

Fig 1-19. Material in abstract drawing
Pen on paper, 5. 1/2 x 8 1/2 in
Illustrated by Shima Rabiee

LINE

MOOD AND CHARACTER

The line's movement and the speed and method of drawing bring about different senses of space. On this basis, a simple drawing leaves a similar impression of the atmosphere of space, dependent on which line it is drawn with.

In sum, it can be said that lines play a significant role in characterizing objects or space and they can shape or control the viewer's perception of space. Hence, it is useful to know the specific features of different lines, to apply them properly and effectively in communicating the mood and character of the space. In this section we get to know some types of line with the aid of examples of works of masters of art. We will see how and why they have used those lines and what impression their work leaves on the viewer. Following this discussion, we will apply these lines for characterizing landscape spaces and see which aspects of landscape space have become tangible and understandable through these lines in a simple sketch.

Figures 1-20 to *1-26* demonstrate a few line types that will be studied in this section.

FIG 1-20. Contour line
Pen on paper, 2 x 3 in

FIG 1-21. Searching line
Pencil on paper, 2 x 3 in

FIG 1-22. Modeled line
Pencil on paper, 2 x 3 in

FIG 1-23. Structural line
Pencil on paper, 2 x 3 in

FIG 1-24. Calligraphic line
Brush and ink on paper, 2 x 3 in

FIG 1-25. Expressive line
Pencil on paper, 2 x 3 in

FIG 1-26. Analytical line
Pencil on paper, 2 x 3 in

FIG 1-20. TO 1-26.
Study of line types in drawings
Various tools , 11 x 17 in
Illustrated by Shima Rabiee

FIG 1-20. Contour line
Pen on paper, 2 x 3 in

• **Contour line** *(Figure 1-20)*:
The simplest and the most effective way of communicating the volume of a concept or a two-dimensional data is to employ these line types. These flowing and free lines are peripheral lines which represent objects or spaces in a general, simple, and rough manner, so that the shape of objects and their relationship with each other as well as with the space are clearly understood. Since they are drawn in a fast and single-time fashion (without back and forth movements of the pen), they are not precise and sizes and proportions they depict cannot be fully trusted. Their main purpose is only to help us understand the objects' overall shape, volume, and spatial composition not the accurate size and proportion.

Figure 1-27 is a beautiful sketch by *Henri Gaudier-Brzeska* who has used this line type to present the form of the anatomy beautifully and expressively with the simplest and least number of pen movements. Although the line is very simple and homogenous and there is no change in its weight, it presents the volume of the anatomy with its entire details in a comprehensive and convincing way. In the same way, we have used this line in the sketch of a golf court in *Figure 1-28*. The flowing and imprecise movements of this line present the organic-ness of the form of the landscape and its different bumps and dents. Also, the volume and mass of the trees in the background are simply shown using this line.

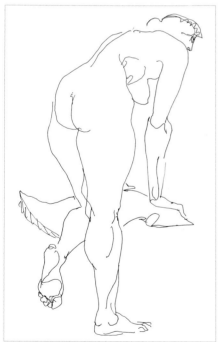

FIG 1-27. Female nude, back view (1911)
Pen and blue ink on off-white wove paper, 10 x 15 in
Gaudier-Brzeska, Henri, French, (1891-1915)
@ Princeton University Art Museum. Photo Credit:
Princeton University Art Museum / Art Resource, NY

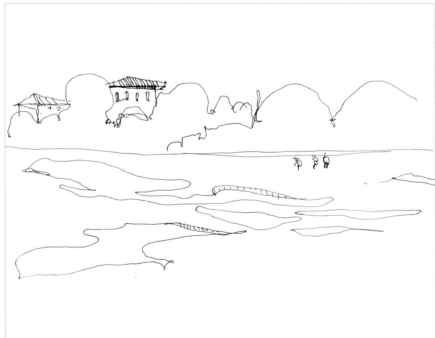

FIG 1-28. Sketch of golf court. Pen on paper, 5 1/2 x 8 1/2 in
Illustrated by Shima Rabiee

LINE

FIG 1-21. Searching line
Pencil on paper, 2 x 3 in

- **Searching line** (*Figure 1-21*):

This line type is created by the pen's continuous movements, the synthesis of which expresses the volume or shape of an object or a space. These lines become then important, when density, texture, and light and shadow are at stake. Since drawing these lines is accompanied by investigating and exploring, they do not represent a precise shape, but always communicate a general impression of mass and openness. In other words, the overall scheme and tone resulting from the combination of these lines with different densities demonstrate the overall shape and sometimes the three-dimensional form through darkness and lightness of lights and shadows.

Georges Seurat's drawings, *Figure 1-29* and *1-30,* exemplify this line type. *Figure 1-30* is a drawing of landscape in which neither the type nor the form of the trees and plants is important. The only important thing here is rather the composition and density of the trees which introduces the quality of the space's light and shadow. This type of image communicates the dynamic and sense of space strongly, while at the same time it offers no precise information about the physical character of the space and the elements in it.

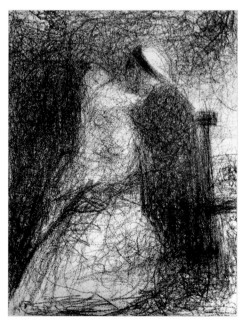

FIG 1-29. Nourrice assise, tenant son poupon
(Seated nurse holding child) (1881-2)
Conté crayon, 12 3/4 x 10 in
Georges Seurat (French 1859-1891)

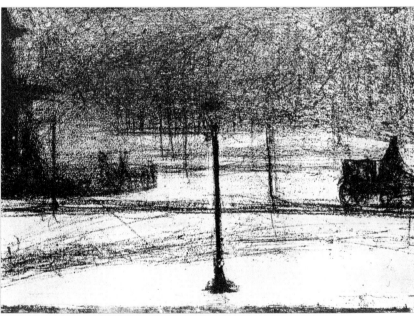

FIG 1-30. Place de la Concorde, Winter (1882-3). Conté crayon, 9 1/8 x 12 in
Georges Seurat (French 1859-1891)

FIG 1-22. Modeled line
Pencil on paper, 2 x 3 in

- **Modeled line** (*Figure 1-22*):

Like contour lines, these lines too represent the outline of objects and spaces, except that they have a more intense articulation and their details become more critical in certain points. This extent of criticalness in these lines helps the artist/designer to represent the forms of objects with more precision.

The other difference between these and contour lines is that drawing these lines calls for a more thorough observation of the three-dimensionality of objects. This ever so slight emphasis of these lines on convexities, concavities and lights and shadows provides a better sense of the three-dimensionality of an object or space for the viewer. From a general overview, these lines are not uniform like contour lines and their thickness varies along them; in other words, they seem to get lost and found on the page.

The extent of this variation in thickness and the reason for it depend on the artist's choice. Their differing line weights are sometimes for the sake of controlling shadow and light; sometimes due to the distance of the objects to the viewer; sometimes for introducing positive and negative spaces; and sometimes simply based on the artist's intuition.

For example, in *Figure 1-31* the variation of line weights signifies the contrast between light and darkness and aims at emphasizing bumps and dents. This helps better demonstrate the three-dimensional volume of the anatomy. The volume and bulk of muscles is beautifully visualized by thicker and higher density lines. In *Figure 1-32*, the thick line separates the ocean and the earth, resulting in the bulging form of the rocks.

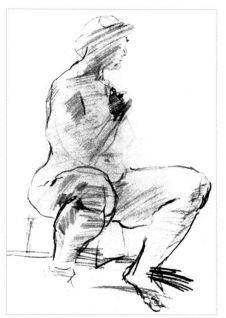

FIG 1-31. Female Nude. Crayon and pencil, 17 1/2 x 23 in. Oskar Kokoschka (1886-1980; Austrian)
Credit: © 2019 Fondation Oskar Kokoschka / Artists Rights Society (ARS), New York / ProLitteris, Zürich

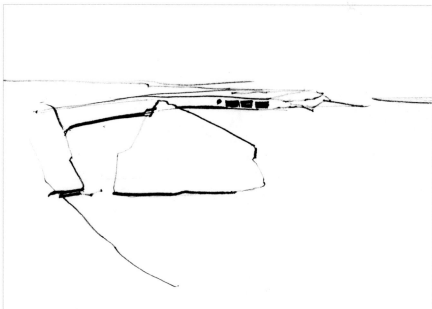

FIG 1-32. Abstract landscape drawing 1
Pen on paper, 5 1/2 in x 8 1/2 in
Illustrated by Shima Rabiee

FIG 1-23. Structural line
Pencil on paper, 2 x 3 in

• **Structural line** (*Figure 1-23*):

These lines demonstrate forms in a simple and geometrical way. Complicated and curved volumes and spaces become simplified with the aid of these lines, because their shapes and compositions can be expressed using a few simple, straight lines. These lines do not offer too many details. The choice of lines and angles plays a significant role in communicating the dynamics of object or space.

General powerful gestures, varying and sharp angles, little details and varying line weights are among the characteristics of these lines which create a rigid, powerful and outstanding sense of space. Drawings made with these lines are generally considered abstract drawings.

These lines appear on paper boldly and strongly, since they are meant to catch the viewer's eye and avoid its distraction by details. *Figure 1-33* is a portrait drawing by *Henri Matisse* and *Figure 1-34* is an alley drawing with the use of these lines. Despite the simplicity and abstractness of the lines, they are drawn boldly, powerfully and with assurance, so that they can satisfy the viewer's need for clarity and render details needless.

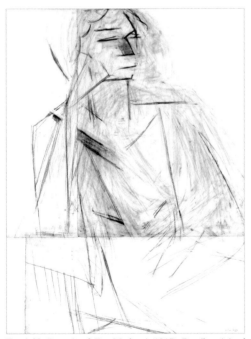

FIG 1-33. Portrait of Eva Mudocci (1915). Pencil on joined paper, mounted to canvas, 36 1/2 x 28 in. Henri Matisse
Digital image © The Metropolitan Museum of Art
Image source: Art Resource, NY
© 2019 Succession H. Matisse/Artists Rights Society (ARS), NY

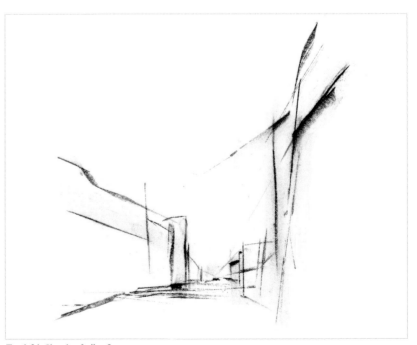

FIG 1-34. Sketch of alley 2
Charcoal on paper, 5 1/2 in x 8 1/2 in
Illustrated by Shima Rabiee

- **Calligraphic line** (*Figure 1-24*):

This approach is taken in order to simply and quickly study objects or spaces. This type of line, although it is drawn simply and freely, possesses a lot of delicacy, complexity and beauty. Many artists have analogized it to a *beautiful handwriting* which, besides its freedom, requires precise and conscious movements. In drawing this line, the brush strokes have sometimes stunt and sometimes sharp ends, they are sometimes made quickly and sometimes slowly, sometimes freely and sometimes precisely. This line type calls for using a special kind of pen which can produce a considerable variety of thicknesses. The variety in line weight enables us to create shapes with simple strokes instead of multiple lines. If thickness variations are made carefully, purposefully and thoughtfully, these lines are capable of creating an extremely beautiful and unique work with different qualities of simplicity and complexity. Working with this line type is difficult and requires mastery, but it is also very exciting at the same time because although the movements of the pen are made consciously and precisely, they are unpredictable to a certain extent and therefore end up in different results.

Figure 1-35 is an example of applying this line on a simple drawing by *Eugene Delacrolx*. The thickness variation of the lines have not only resulted in delicate details, but also demonstrates the volume and form of the dress beautifully using shadow and light. The brush strokes are rough and simple, but very effective in creating mood, movement and powerful dynamics to the drawing. *Figure 1-36* is a simple sketch of studying an alley; despite its simplicity, it beautifully communicates the form and spatial structure of the alley using this line type.

FIG 1-24. Calligraphic line
Brush and ink on paper, 2 x 3 in

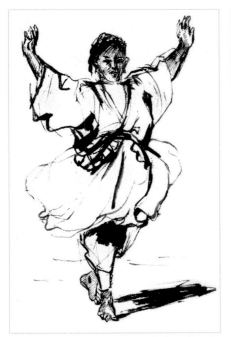

FIG 1-35. Arab Dancer, 1832. Pen and ink, 7 1/2 x 6 in.
Eugène Delacroix' (French, 1798-1863)
Museum Boymans-van Beuningen, Rotterdam

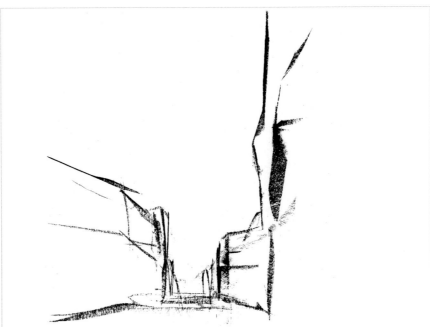

FIG 1-36. Sketch of an alley 1
Charcoal on paper, 5 1/2 x 8 1/2 in
Illustrated by Shima Rabiee

LINE
MOOD AND CHARACTER

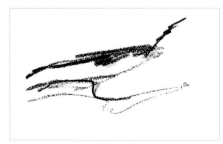

FIG 1-25. Expressive line
Pencil on paper, 2 x 3 in

- **Expressive line** (*Figure 1-25*):

Space is most beautifully and effectively represented by expressive lines since they can communicate movement and atmosphere as well as depicting the physical character of spaces and objects. This expression usually results from a set of lines with different characters which amplify and complete each other. Flow, speed, movement, pause and line weight in making the strokes and even the way the pen moves all depend on the artist's choice, passion, and his/her view of the subject of drawing. Since these lines are drawn quickly and smoothly, they are accompanied by back and forth movements or investigations of the pen. Hence, despite their combinations and complexities, they do not offer a precise form of object/space. This multiplies the beauty of the work, because it allows the viewer to imagine other possible conditions as well: conditions that the viewer would rather see in the work. *Figure 1-37* shows how different anatomical gestures and the sense of movement and animation are communicated to the viewer by means of expressive lines. Simultaneously to being very sketchy and rough, the sketch not only presents the shape of the portrait beautifully, but it also succeeds in communicating a strong mood, dynamics, energy, and movement of the dancer using this line type.

These lines can also be used in landscape drawing to communicate something more than the physical character of the space. *Figure 1-38* communicates the sense of dynamism and movement in the space to the viewer to some extent. In this sketch, expressive lines help the viewer capture the sense of a windy atmosphere represented in the movement of grass, trees and other elements, in addition to understand the physical character of the space.

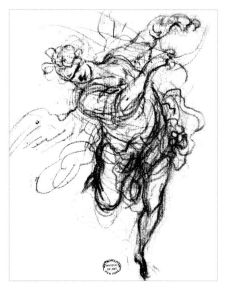

FIG 1-37. Angel (Recto). Red chalk on cream paper, 6-3/4 x 5-5/16 in. Anonymous (16th century, Italian) Gift of Cornelius Vanderbilt, 1880 (80.3.72, recto) @ The Metropolitan Museum of Art, New York, NY Copyright © The Metropolitan Museum of Art Image source: Art Resource, NY

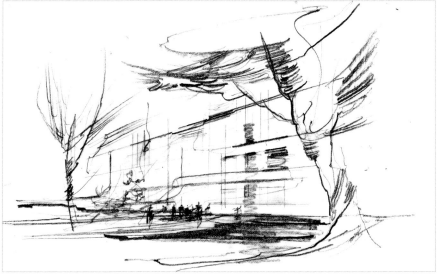

FIG 1-38. Landscape drawing. Pencil on paper, 8 1/2 x 11 in. Illustrated by Shima Rabiee

FIG 1-26. Analytical line
Pencil on paper, 2 x 3 in

- **Analytical line** (*Figure 1-26*):

Analytical lines are a set of exploring and faint lines which describe a position, a concept, or a complex. With these lines, the precision of form is less important than the entirety of volumes and the mass resulting from their composition, which in turn define the negative and positive spaces. When drawing these lines, it is the relations between structures, the mass of the volumes' composition and the negative and positive spaces between these volumes that should be considered rather than the forms of individual volumes. The impreciseness, faintness, and looseness of the sum of these lines drawn with alternating motions help the viewer imagine other alternatives to the design concept and prevent him/her from freezing the shapes and considering the image as the final state of design. These lines do not present many details. Their beginning and end points as well as their points of intersection are more emphasized. This emphasis on the edges of volumes and the intersections of structures enhances the perception of the three-dimensional volume of objects and their connections. The following images, *Figure 1-39* and *1-40*, show examples of these lines in the presentation of an interior space and an urban space. *Alberto's* sketch shows how these vague and unclear lines can offer the viewer a strong sense of the composition of volumes and their density in space. This approach can also be used in architecture and landscape drawings, where we want to communicate the sense of space and the composition of its mass without offering a final and finite design to the viewer. *Figure 1-40* is an example of this approach.

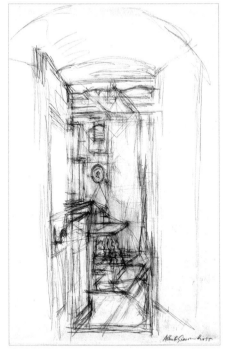

FIG 1-39. An Interior (1955). Pencil on paper, 19 3/4 x 12 7/8 in. Alberto Giacometti (1901-1966). © VAGA at ARS, NY. The Joan and Lester Avnet Collection, @ The Museum of Modern Art, New York, NY Digital Image © The Museum of Modern Art/ Licensed by SCALA/Art Resource, NY

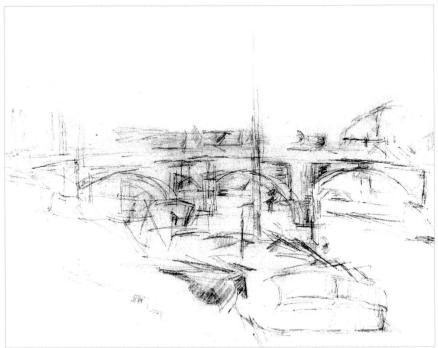

FIG 1-40. Quais avec pont et barque. Paul Cezanne
The Arkansas Arts Center Foundation,
Collection: The Fred W. Allsopp Memorial Acquisition Fund

TONE

The extent of lightness or darkness of objects is called *Tone* or *Value*. Tone has to do with the surface and not with line. Many of design concepts are not communicable with lines alone. This is where tone comes in handy. The following drawings, *Figure 1-42* and *1-43,* exemplify the effect of tone in representing and communicating the sense of space through light and shadow.

Tone is a relative concept, because darkness and lightness are relative concepts in themselves. If we represent darkness with the color black and lightness with the color white, numerous gray tones exist between these two which are the result of different combinations of black and white. The greater number of gray tones we create, the more control we have over the drawing tool and therefore we can apply tone more effectively in expressing the design intent. The following table, *Figure 1-41,* is an example of eight different value scales created between black and white.

Black	Gray	White

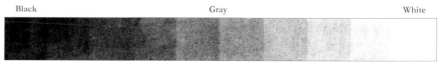

FIG 1-41. Value scale

The more square we can create between the black and white with various and distinct tone, the better we control the tone in the drawings.

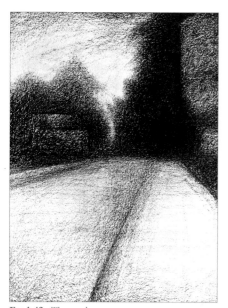

FIG 1-42. The road
Georges Seurat (French, 1859- 1891)

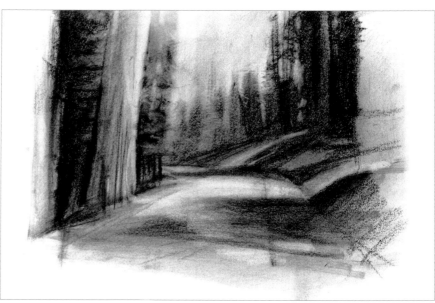

FIG 1-43. Drawing of Redwood Regional Park
Charcoal on paper, 11 x 17 in
Illustrated by Shima Rabiee

• **Applications of tone in visualization:**

Using tone, it is possible to communicate important factors of design such as depth, three-dimensionality of space, texture, density, material, shadow and light, and even aesthetic, graphical and compositional concepts of the design presentation. In this chapter, we study the tone, the darkness and lightness, to communicate the following three concepts, which are among the most effective factors in visualization, and we elaborate on these concepts:

1. Creating depth: By controlling the lightness and darkness of objects, we can signify their distance to the viewer and this enables us to create a sense of depth and three-dimensionality of space on two-dimensional (orthographic) and three-dimensional (perspective, isometric, and axonometric) drawings *(Figure 1-44)*.

2. Expressing form: Using tone in the form of light and shadow, it is possible to reveal the form of objects and their relations to each other in space. Light and shadow also contribute to better communicating the sense of the space *(Figure 1-45)*.

3. Enhancing the composition and creating point of interest: Using tone, it is also possible to control and guide the movement of the eye across the page by using different darkness and brightness, which emphasizes the image's main point and makes the composition of the image aesthetically pleasing and more expressive *(Figure 1-46)*.

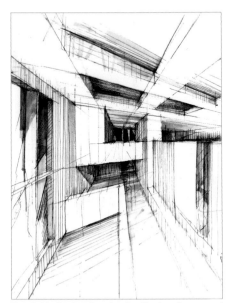

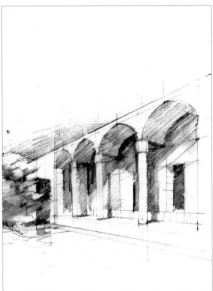

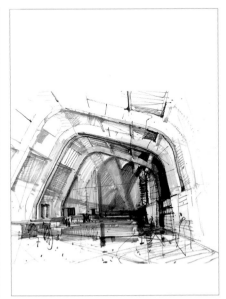

Fig 1-44. An interior sketch, (Study of tone and depth). Pen and marker on paper, 11 in x 17 in Illustrated by Shima Rabiee

Fig 1-45. Outdoor sketch, (Study of tone and expression of form). Pencil on paper, 8 1/2 in x 11 in Illustrated by Shima Rabiee

Fig 1-46. (Study of tone and composition). Pen and marker on paper, 11 in x 17 in Collaborative work with students at freehand drawing workshops

TONE

• Compatible tools for creating tone:

Tone can be created using different tools (*Figure 1-47*). The easiest way for demonstrating tone is to use tools which can produce different qualities of line weight and darkness, meaning that they can cover considerably large areas with minimal movements, and that they offer the possibility of controlling the tool's pressure on paper and hence controlling the darkness of surfaces. Therefore, charcoal is a better choice for toning than pencil, and pencil is better than mechanical pencils or rollerball pens. The reason is that charcoal requires a small range of hand motion and it allows for tones to be produced more quickly and with higher control over the lightness and darkness of surfaces (*Figure 1-37*).

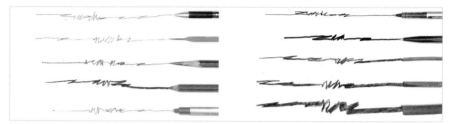

Fig 1-47. Drawing tools study. Pen, pencil, charcoal and ink, 11 in x 17 in

It is also possible to create tone using other tools which do not offer a variety of line weights and only produce monotonous lines, mainly through drawing hatches and thereby achieving different dark tones. The following drawings of the portrait and landscape space, *Figure 1-48* and *1-49*, exemplify this method of creating tone through drawing lines and hatches.

Fig 1-48. Portrait drawing,
Willow and compressed charcoal on Bristol paper,
18 x 20 in
Illustrated by Shima Rabiee

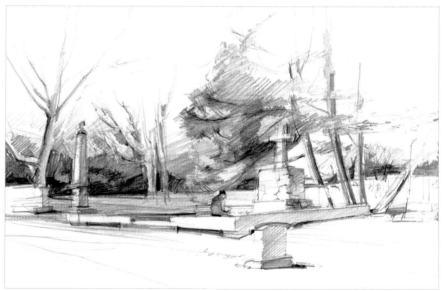

Fig 1-49. Landscape Drawing
Pencil on Bristol paper, 18 x 20 in
Illustrated by Shima Rabiee

Each tool possesses the ability to create different tones. As we mentioned in this discussion, tools such as pencil or charcoal can create different tones by applying various pressure on the paper, or changing the thickness or angle of the tip. Other sharp-pointed tools with a constant line weight which can only draw homogeneous lines, can also create tone by drawing textures and hatches. Different hatching methods and densities can create different tones. The following examples on *Figure 1-50* show a number of methods for creating different tones using various tools.

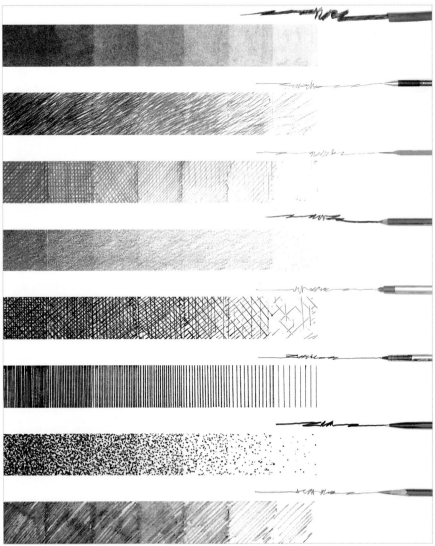

FIG 1-50. Methods of creating tone with various tools
Pen, pencil, marker and charcoal, 11 in x 17 in
Illustrated by Shima Rabiee

It is important to note here that each tool has a variety of specific characteristics. If we know the drawing tool well and have a comprehensive understanding of its uses and potentials, we can use it effectively for creating tone, texture, and mood in the image. Making correct use of tools in presenting a space can help communicate the sense of place to the viewers.

The following drawings in *Figure 1-51* offer examples of the implementation of tone with different tools and techniques. Many other styles and techniques can be discovered and added to these examples.

The following drawings are introducing a rural/urban fabric with the aid of pen, pencil, charcoal, marker, and brush and ink on papers. Each technique introduces the space in a different way. *Drawing B*, which is done by charcoal, communicates the sense of fear, insecurity and mysteriousness of the fabric, whereas *Drawing D*, which is done by pencil, communicates the sense of a friendly and peaceful rural fabric. *Drawing C*, done by brush and ink, stresses the oldness and archaicness of the fabric.

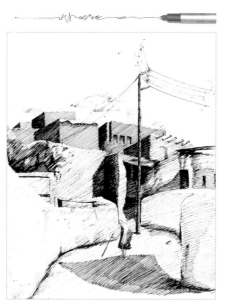

Drawing A: Pen on paper

Drawing B: Charcoal on Bristol paper

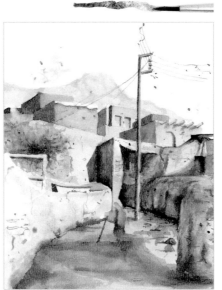

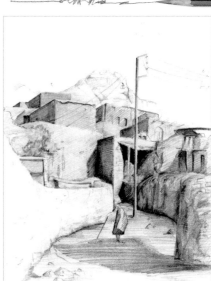

Drawing C: Brush and ink on Bristol paper

Drawing D: Pencil on paper

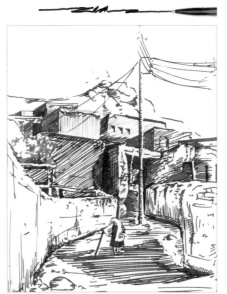

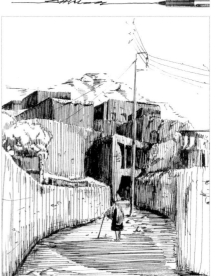

Drawing E: Marker on paper

Drawing F: Pen on paper

FIG 1-51. Series of drawings from Abyaneh village with various tools (Drawing A to F)
8 1/2 x 11 in
Illustrated by Shima Rabiee

DEPTH (ORTHOGRAPHIC DRAWINGS)

One of the uses of tone is to recognize the depth/distance of elements to the viewer through applying different light and dark shades on two-dimensional surfaces. To understand the concept of depth in two-dimensional images, compare the two following diagrams, *Figure 1-52* and *1-53*.

In *Figure 1-52*, a series of geometrical shapes are seen which appear two-dimensional and flat on the page. Once we assign different values to these shapes in *Figure 1-53*, they do not seem to be placed on a flat surface anymore, but rather appear to be situated at different distances, hence giving the viewer a sense of three-dimensionality in the image.[1]

FIG **1-52.** Geometrical shapes
Pen on paper, 2 1/2 x 2 1/2 in

FIG **1-53.** Geometrical shapes with various tones creates illusion of depth

This technique can be useful in drawing and presenting all different kinds of design drawings, ranging from orthographic projection drawings such as plan, elevation and section to three-dimensional projections such as isometric and axonometric drawings, to architectural and urban perspectives. In presenting a two-dimensional drawing such as plan, elevation and section, creating a three-dimensional understanding of the elements and their structure through tone is more important than beautiful coloring and rendering. For example look at the two images, *Figure 1-54 and 1-55*, to better understand the application of tone in creating illusion of depth in an architectural plan.

Figure 1-54 is a larger diagram of the above statement about the tone and its influence in creating illusion of depth. *Figure 1-55* demonstrates a simple presentation of architectural plan, implementing various tones/values to create depth and a sense of three-dimensionality.

1. Goldstein, Nathan. *The Art of Responsive Drawing.*
5th edition. New Jersey: Prentice Hall, 1999.

It is generally believed that in a two-dimensional image, black objects appear closer and white ones further away, as *Figure 1-54* shows. Hatched shapes seem to be situated at a distance between these two and based on the density of their hatches and their blackness or whiteness, they appear closer or further away.

But, in orthographic architectural drawings which consider the sun as light source, this principle gets reversed, which means that darker objects appear further away and deeper within the space, and lighter and whiter ones seems closer and brighter. For example, look at *Figure 1-55*. The black squares demonstrate deep fountains and the white circles demonstrate the trees which are high and are therefore felt closer to the viewer. The space between these two is the lawn which is hatched and has a medium tone.

Note that the principle of tone scale in drawing is a relative one and sometimes changes due to reasons such as color, roughness or softness of the texture, material, density of the elements, etc. Therefore, complying with this principle is recommended and not obligatory.

Fig 1-54. Geometrical shapes with tone creates three-dimensional illusion
Pen on paper, 3 in x 5 1/2 in
Illustrated by Shima Rabiee

Fig 1-55. Site plan drawing
Pen on paper, 8 1/2 in x 5 1/2 in
Illustrated by Shima Rabiee

Usually in architectural plans, besides introducing the lightness and darkness of the surfaces, the shadow and light of the elements are also used for creating a sense of depth. For better understanding this, compare the following three diagrams with each other.

- *Figure 1-56* demonstrates a plain and technical plan which simply includes a set of different shapes and seems flat.

- *Figure 1-57* demonstrates more details of the elements constructing the plan. The texture and the details drawn on the surfaces have created different lightnesses and darknesses on them and help distinguish these surfaces from each other, preventing the image from appearing flat.

- *Figure 1-58* demonstrates a plan with elements of different heights. The height of the elements which construct the plan can be demonstrated by applying shadow and light on them and thereby creating a stronger sense of three-dimensionality in the plan.

The following drawing, *Figure 1-59*, is another example of the urban design plan rendered by various tones/values.

FIG 1-56. Site plan I; Basis lineworks imply a two-dimensional image.
Pen on paper, 5 in x 3 in

FIG 1-57. Site plan II; Tone of texture and detail creates three-dimensional illusion.
Pen on paper, 5 in x 3 in

FIG 1-58. Site plan III; Light and shadow enhances the three-dimensional illusion
Pen on paper, 5 in x 3 in
Illustrated by Shima Rabiee

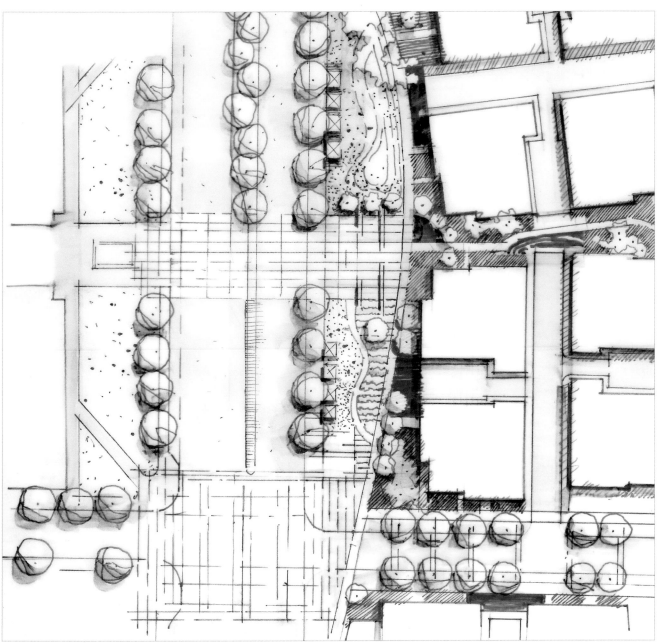

Fig 1-59. Site plan
Foster City Mixed Use
Pen and marker on vellum paper, 8 1/2 in x 11 in
Illustrated by Shima Rabiee, Copyright to SWA Group

TONE

DEPTH (THREE-DIMENSIONAL DRAWINGS)

Tone is also an effective tool to create depth in three-dimensional drawings, as well as orthographic drawings. Applying different light and dark shades, especially in isometric, axonometric and perspective drawings, helps us communicate a clearer sense of the sequence and order of objects in relation to each other as well as to the viewer. Tone thereby allows the viewer to better recognize the depth of space and the order of the elements' placement in it. Generally, value changes based on the distance of objects to the viewer. Based on the intention of the artist and the subject matter of the illustration it changes from light to dark or from dark to light. *Figure 1-60* and *1-61* demonstrate two approaches to presenting depth using tone, and the following drawings of *Georges Seurat, Figure 1-62* and *1-63,* exemplify each approach in a simple and beautiful way.

In *Figure 1-60* and *Figure 1-62* the background, which is the farthest plane to the viewer, is the lightest layer of the image and the other elements and layers become darker

FIG 1-60. The concept of creating depth from dark to light.

FIG 1-61. The concept of creating depth from light to dark.

FIG 1-62. Café-Concert. Conté crayon and white gouache on buff laid paper, 9 3/16 x 12 1/16 in Georges Seurat (French, 1859- 1891). Credit: Harvard Art Museums/Fogg Museum

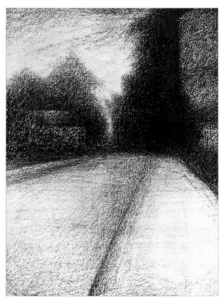

FIG 1-63. La route (The road) Georges Seurat (French, 1859- 1891)

as they get closer to the viewer. On the contrary, in *Figure 1-61* and *Figure 1-63* the foreground, which is the closest plane to the viewer, is the lightest layer of the image and other volumes and points in the image get darker as they move away from the viewer and towards the background.

In the first scenario, where the background is lighter, distant objects are presented more dimly and closer ones more clearly and with higher contrast. Refer to *Figure 1-64* and *Figure 1-65* as other examples of this approach. In *Gaetano Gandolfi's* drawing in *Figure 1-64*, in order to present the depth of space more strongly, the human figures

FIG 1-60.

FIG 1-64. Figures and animals in deep architectural setting (18th-19th century)
Brown ink, pencil and gray wash, 21 1/8 x 29 1/2 in
Gaetano Gandolfi
Los Angeles County Museum of Art, Los Angeles County Fund (54.12.15)
Photo © Museum Associates/ LACMA

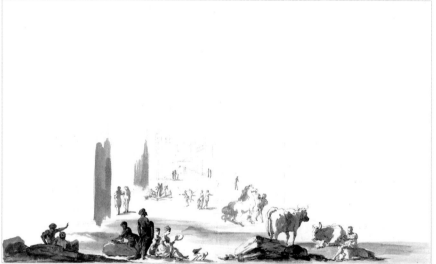

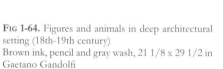

FIG 1-65. Emaar Hills Landscape Development, UAE
Digital media, 17 x 24 in
Illustrated by Shima Rabiee, Copyright to SWA Group

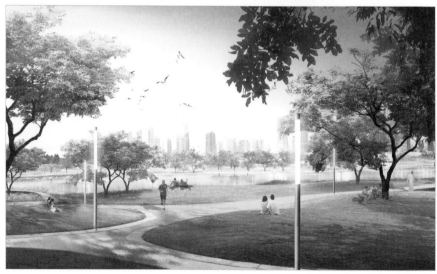

and animals on the front plane have more saturated colors, contrast, and more details, whereas the elements on the planes which are further away (the trees, human figures and the architectural lines), are presented with fainter lines and less detail. And this has increased the sense of depth in perspective view. This principle is applied in *Figure 1-65,* a digital rendering, as well. Note how, as the objects move towards the depth of the space, they gradually become lighter, and how this increases the three-dimensional sense of the image.

In the second scenario, *Figure 1-61,* where the foreground is brighter and more important, this principle is applied reversely; meaning that distant objects appear fainter, darker, have less details and are more unsharp and dim, whereas closer objects are presented more boldly, sharply and with more light, contrast and details. *Figure 1-66* is a drawing of *Eugène Delacroix* that demonstrates this concept of creating illusion of depth from light to dark beautifully. *Figure 1-67* and *1-68,* are also two examples of this scenario of creating illusion of depth though gradual tone scale in an indoor and outdoor spaces. Please note that in both approaches explained in *Figure 1-60* and *1-61,* it is important to note that darkness and lightness should be applied gradually and based on the

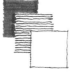

FIG 1-61.

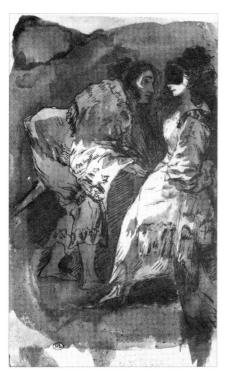

FIG 1-66. Eugène Delacroix (French, 1798-1863)
Masquerade (after Francisco Goya, Nadie se Conce)
Pen and ink with wash 7x4 1/4 in
Louvre Paris

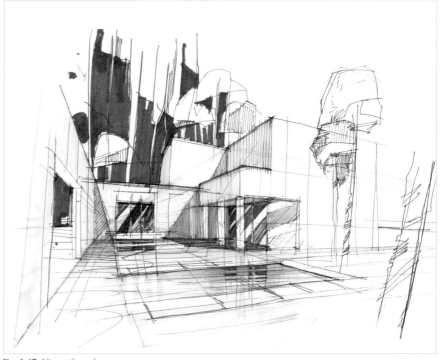

FIG 1-67. View of outdoor space
Pen and marker on paper, 11 in x 17 in
Illustrated by Shima Rabiee

order of the elements' placement in space, so that no confusion is brought about in understanding the space and the position and relation of the elements. The choice of tone—from light to dark or from dark to light—depends on the drawing's subject matter and the artist's choice. If toning is applied with great attention and care, the depth of space would turn out expressive and comprehensible.

FIG 1-61.

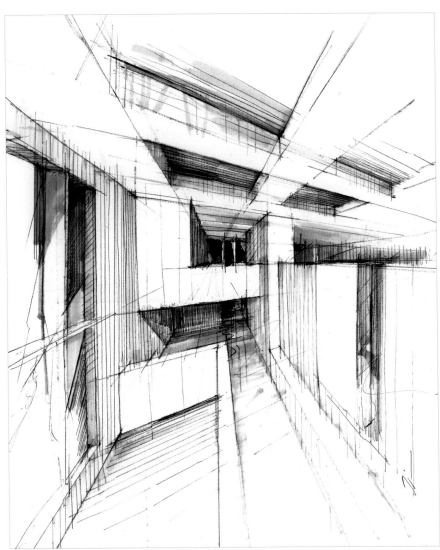

FIG 1-68. An interior (tone and depth)
Pen and marker on paper, 11 in x 17 in
Illustrated by Shima Rabiee

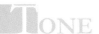

TONE

LIGHT AND EXPRESSION OF FORM

One of the ways to better define the three-dimensional form of objects is through applying shadow and light. Shadow and light help not only present the three-dimensional form of objects more distinctly, but also understand the relation of objects to their surroundings and other adjacent objects more precisely.

The examples below demonstrate how applying the different values created by light on a figure drawing, *Figure 1-69* by *Rembrandt,* and an architectural space, *Figure 1-70,* has led to a better definition of their three-dimensional form.

The principle of shadow and light is consistent everywhere and affects all forms and spaces in one and the same way. Familiarity with this principle helps you find the value scale more easily, hence being able to present the form more quickly. The optimum form for studying the principle of shadow and light is a sphere. As you can see in *Figure 1-71*, six different value scales have appeared on the sphere, which beautifully present its three-dimensional form on a two-dimensional surface. These value scales as demonstrated in *Figure 1-71* are as follow:

Highlight, Light, Shadow, Core of shadow, Reflected light, and Cast shadow.

This principle of value scale applies to all other volumes, cube, cone, and cylinder as well.

FIG **1-69.** Woman carrying a child downstairs, 1636
Pen and brown ink and brown wash, 73 2/5 x 52 in
Rembrandt (1606-1669)
The Pierpont Morgan Library, New York

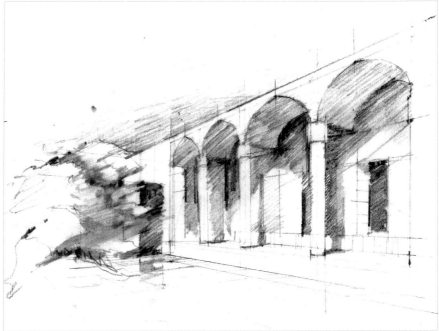

FIG **1-70.** Sketch of outdoor space
Pencil on paper, 8 1/2 x 11 in
Illustrated by Shima Rabiee

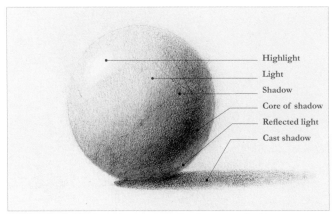

FIG 1-71. Study of value scales on sphere. Pencil on paper, 5 x 8 in
Illustrated by Shima Rabiee

The extent and intensity of shade and shadow created by light is determined by the following factors *(Figure 1-72)*:

- **Intensity of light :** Wherever there is light, there is also shadow, and hence there are different tones. In the same way, wherever the intensity of light is higher, the shadow is darker and hence the contrast between darkness and light is greater *(Drawing A).*

- **Distance to the light source:** Sunlight, which is considered a light source at infinite distance and therefore with parallel light rays, creates smaller shadows than spotlights. The closer the light source gets to the object, the bigger and more deformed does its shadow become and vice versa *(Drawing B).*

- **Direction of light:** The more vertically light rays shine on the object, the shorter the shadow gets. Noon light, when the rays of the sun shine nearly vertically, or sunset light, when the angle of rays is too sharp, are not recommended for sketching or photography *(Drawing C).*

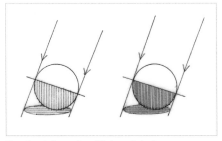

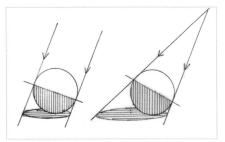

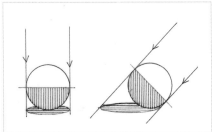

Drawing A: Intensity of light and shadow Drawing B: Distance of the light source Drawing C: Direction of light

FIG 1-72. The influential factors on the extent and intensity of shade and shadow (Diagram A, B, and C)
Pen on paper, 2 x 5 in, Illustrated by Shima Rabiee

TONE

COMPOSITIONAL ENHANCEMENT

Given the general belief that the eye subconsciously discovers the darker spots first, sometimes variations of value scales (variations of darkness and lightness) are applied for controlling the composition or for moving and leading the eye across the page or towards the target of the image. Despite the two applications of value which were introduced earlier and which were based on a logic, this kind of value change is applied based on the decision of the designer/artist and the purpose of the image, and it does not follow specific rule or principle. In this kind of value variation, note that:

- The darkness and lightness of the spots in the image should be continuous, so that they do not cause gaze.
- The range of value change on these points should be compatible with that of the entire image. For example, if the image contains five different value scales, the value in the point of emphasis should also be in the range of the existing tones, so that it does not lead to daze or the confusion of harmony.

To better understand this discussion, refer to the *focal point* studied in chapter two.

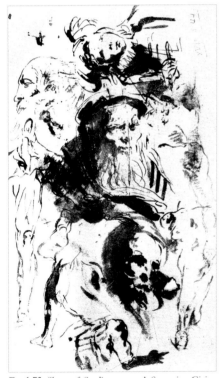

FIG 1-73. Sheet of Studies; verso: A Sovereign Giving Audience. Brown ink and brown wash on cream antique laid paper, 13 7/8 x 9 1/4 in. Giovanni Domenico Tiepolo. Credit Line: Harvard Art Museums/Fogg Museum, Gift of Dr. Denman W. Ross. Copyright: © President and Fellows of Harvard College

FIG 1-74. Study of tone and composition 2
Pen and ink on Bristol paper, 11 x 17 in
Illustrated by Shima Rabiee

The following examples of this discussion demonstrate this kind of value change in order to enhance the composition and create more vigor and excitement in the images *(Figure 1-73, 1-74 and 1-75)*.

FIG 1-75. Study of tone and composition 1
Pen and marker on paper, 11 x 17 in
Collaborative work with students at freehand drawing workshops

FORM

INTERNAL FORM

The three-dimensional shape of the object or space is called *Form*. Designers usually rely on two different concepts of form for expressing the shape and three-dimensional structure of objects/space. Familiarity with these concepts helps make the visualization more expressive. These two concepts are: *External Form* and *Internal Form*.

The first definition of *Internal Form* is the *Contour Lines*, a set of parallel lines tangent to the outer form of objects or space, which move along the latter's three-dimensional forms. Drawing these lines requires total familiarity with the form of all of the single volumes as well as mastery of the principles of perspective. For effectively implementing these lines which enhance visualization, it is necessary to bear the following points in mind:

- **Contour lines are parallel and continues:**

Note that contour lines are always parallel to each other and never intersect. They move continuously across the entire image and are drawn compatibly with the direction of the texture and form of the volumes. As pointed out above, the method of drawing these lines is a direct outcome of a comprehensive understanding of the form of volumes and the rules of perspective. Look at the following images; *Figure 1-76* is a simple and expressive illustration of the form of the portrait done by *Harold Tovish* with contour lines. *Figure 1-77* demonstrates how these lines can be applied to illustrating urban spaces.

- **The density and thickness of contour lines leads to value change, a sense of depth and a sense of shadow and light:**

The second principle we should keep in mind while drawing these lines, is their density. The denser and thicker these lines are, the darker the value gets which these lines create

FIG 1-76. Contour Drawing (1972). Pencil, 19 x 25 in
Harold Tovish (1921)
Terry Dintenfass Gallery, New York

FIG 1-77. Study of internal form of an urban space. Pen on paper, 11 x 17 in
Illustrated by Shima Rabiee

on surfaces, and the thinner and less dense the lines get, the fainter does the value created by them seem. Given the previous discussion regarding value, this change in value scale sometimes creates a sense of depth in the space, sometimes leaves the impression of shadow and light, and sometimes affects the image's composition and visual weight. Understanding these effects while drawing these lines is necessary and helpful (Refer to *Figure 1-78* as an example).

• **The precision of the lines introduces the materials and possibly scale of the space:**

If the surface is composed of smaller elements, the lines can be drawn in correspondence with the length of these elements and their distance, so that they better introduce the material of that surface. For example, the distance between parallel lines on the flooring should rather be based on the dimensions of the tiles to better introduce the space and its scale and materials and offer the viewer a more effective representation of understanding the space. *Figure 1-78* is an example of drawing interior space with the aid of these contour lines.

***These lines can also be applied in digital presentation. To better understand the role of these lines in digital presentations, refer to the example 1, steps 2 and 3 in chapter 3.*

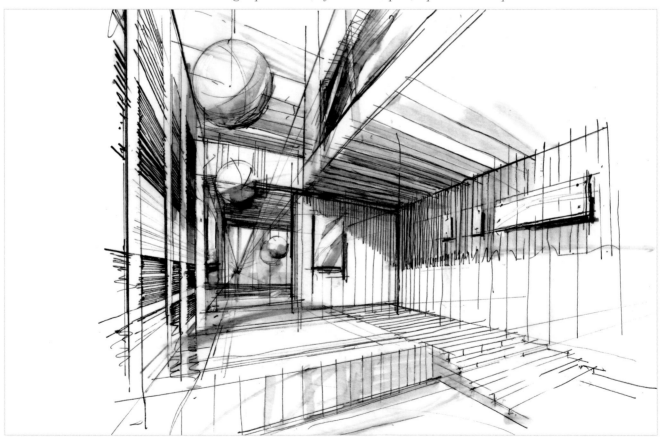

Fig 1-78. Study of interior space with contour lines
Pen and marker on paper, 11 x 17 in
Illustrated by Shima Rabiee

FORM

EXTERNAL FORM

The nearest definition for *External Form* would be *Positive and Negative Space*, i.e., lines which define/demarcate the borders of intended objects and separate them from their surrounding environment and thereby make them stand out.

Look at the following examples which demonstrate how these lines should be used to better and faster introduce the overall form of an object or the space. *Figure 1-79* is a work of *Josef Albers* and is a highly abstract but expressive representation of the form of a portrait. It demonstrates the three-dimensionality, form and details of the face beautifully and comprehensively with a continuous line, so that the viewer does not need to actually see further details of the face and can infer the form and composition of the face from the single line which has drawn it. In the same way, as you can see in *Figure 1-80*, the form and spatial composition of an urban space can be presented simply, comprehensively, and expressively by making this very simple line stand out.

These lines have varying weights; In the following situations they are drawn with the heaviest weights:

- Where the contrast between light and shadow is high. In other words, the more intense the light source is, the more contrast between the objects and the bolder the differentiating lines are.
- The more distant the target is from that of other objects in the image, the bolder its external lines are drawn. To better understand this concept, look at *Figure 1-82* and how the differing lineweights in it demonstrate different distances between objects in space.

FIG 1-79. Self-Portrait. Brush and ink, 7 3/4 x 11 1/2 in. Josef Albers, (1888-1976, German-American) Credit: © The Josef and Anni Albers Foundation / Artists Rights Society (ARS), New York, 2019

FIG 1-80. Study of external form of an urban space Pen on paper, 11 x 17 in Illustrated by Shima Rabiee

Note that the external form is not only applied in the freehand technique using lines, but it is also widely applied in digital presentation. The only difference is that in digital presentation, the element separating negative and positive spaces is not the line, but rather other factors such as variation of tone, different temperature of colors and etc. which differentiate positive and negative spaces effectively.

- **Summary and comparison of internal and external form:**

As you can see the following drawings, *Figure 1-81* and *1-82,* are made from the same space, and they express the form of their subject in different ways. The external lines express the general form of objects/space and the mass and openness of the overall composition, whereas the internal lines express the relationships of objects to each other and to the space. Each helps develop a better understanding of the space in their own way and hence they are both effective in presenting and communicating the space.

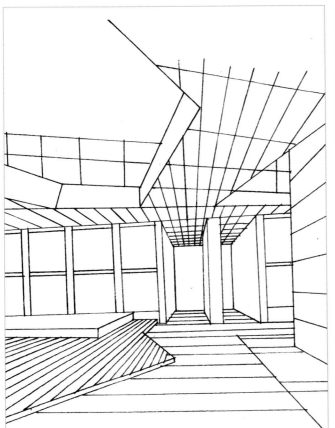

FIG 1-81. Study of internal form, sketch from McMurtry Building at Stanford University. Pen on paper, 8 1/2 x 11 in
Illustrated by Shima Rabiee

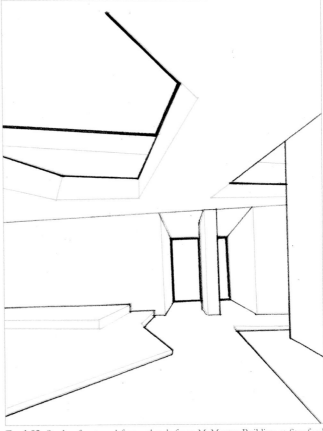

FIG 1-82. Study of external form, sketch from McMurtry Building at Stanford University. Pen on paper, 8 1/2 x 11 in
Illustrated by Shima Rabiee

APPLICATION OF
ART PRINCIPLES
IN VISUALIZATION

Chapter II:

Application of Art Principles in Visualization

The simplicity and abstractness of the illustrations studied in the previous chapter are not the only elements playing a vital role in communicating an idea; of equal importance is the presentation of the illustrations, which in turn controls or directs the viewer's reading and interpretation of the image. Factors—such as placement, composition, contrast, etc.—act as artistic tools that contribute to the quick and straightforward fulfillment of the illustrations' objective, which is studied further in this chapter as to facilitate the communication of ideas in the design studio. These principles, along with their respective methods and effects, are broken down and are theoretically and illustratively analyzed in this chapter.

The sum of these principles—listed below—is what is recognized as composition and it plays a significant role in any visualization and presentation.

- Frame
- Placement
- Scale
- Dynamic and Energy
- Negative and Positive
- Color
- Harmony
- Contrast
- Focal Point
- Compositional Gestures
- Spatial Structure
- Grouping and Direction
- Illusion of Depth
- Visual Weight and Movement

Although it is important to know all the principles, an effective presentation does not necessarily follow all of them, but rather, it chooses the ones it requires and applies them purposefully.

RAME

The first step in presenting an idea is choosing a proper shape for its *Frame*. With the aid of the image's frame, we determine how to view the image and what to expect from its content. In this process of selecting the frame the two following factors are important:

- **The shape of the frame:**

Each geometric shape (square, rectangle, circle, trapezoid, etc.) has their own specifications and when they frame an image, they produce different responses from viewers that influence the interpretation of the image. For example a vertical rectangle gives an impression of balance, dignity, and scale, whereas a horizontal one generate the sense of infinity, movement, calmness, and continuity. The square exemplifies symmetry, balance, steadiness, and limitedness, whereas a circle conveys energy, movement, imbalance, infinity, virtuality and centrality *(Figure 2-1)*.

Influential in nature, geometric shapes often aid in expressing and communicating design intentions and ideas.

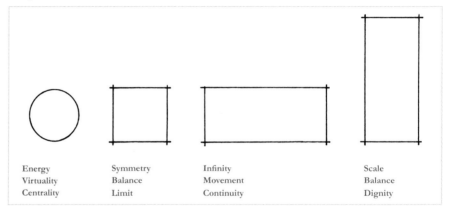

Energy	Symmetry	Infinity	Scale
Virtuality	Balance	Movement	Balance
Centrality	Limit	Continuity	Dignity

Fig 2-1. Geometric shapes
Pen on paper, 8 1/2 x 11 in

- **The movement of the frame:**

The shape of the frame also determines the movement or directional gaze toward the surface; and whichever side of the image is stretched, the eye likewise will move in that direction. Circular, square, and similar framing, which have a symmetrical geometry from all sides, usually function neutrally. The visual force and gravitation of these shapes is constant in all points, and therefore the gaze is fixed in the center. But in the case of shapes—such as rectangle, where the framing is lengthened in one direction—the eye moves in the same direction as the image's elongation.

A horizontal rectangular frame intensifies the horizontal orientation of the gaze and a vertical rectangular frame intensifies the vertical one. It is worth noting that the more elongation the rectangle has, the more intensely this force impacts the gaze, that is, a rectangle with a 4:1 ratio motivates eye movement more than one with 2:1. In a

trapezoid frame or a frame with an indefinite geometric shape, the gaze orientates itself towards the sharper corner of the frame.

The following diagrams in *Figure 2-2* illustrate the movement of the gaze in different frames.

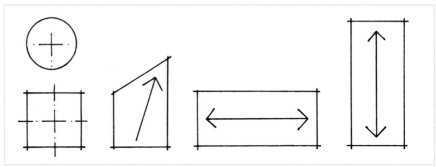

FIG 2-2. The effect of geometric shapes on eyes movement
Pen on paper, 8 1/2 x 11 in

The two examples below, the narrow alley in *Figure 2-3* and the open flexible seating zone in *Figure 2-4*, are images that illustrate the various directions of a rectangle frame and demonstrate their influence on the impression of the space, and the manipulation of the eye's movement toward the design elements.

FIG 2-3. Sketch of urban space
Pen and marker on paper, 8 1/2 x 11 in
Illustrated by Shima Rabiee

FIG 2-4. The Plaza at Harvard University, MA, USA
Digital media, 11 x 17 in
Illustrated by Shima Rabiee; Copyright to Stoss LU

Placement

Situating an object or a space within a specific frame is called *Placement*. While observing an image, we do not look at all its points equally. Some points are more inviting to the eyes than others, and therefore they can play an important role in the image's composition and its communicative purpose.

It is common knowledge that many of these art principles thus discovered were actually originated within nature, which in turn offers the most beautiful and complete proportions and relations. The following images are just some from thousands of examples in nature which follow this rule *(Figure 2-5)*.

Fig 2-5. Natural forms
Photo credit to Pexels

Artists too, after years of study and creating numerous works after being inspired by nature, have reached common conclusions about desirable dimensions and proportions. These ratios are thought to be the most aesthetically attractive, and create a notable balance and harmony when used that aid in manifesting comfort. Designer can use these proportions and ratios to present their ideas intentionally, in a way that will transpire their purpose.

Knowing these proportion translates to knowing how the eye naturally feels most comfortable with them. However, this does not mean that these are necessary and unavoidable rules. They can be altered based on the designer's purpose of communication, the image's aesthetics, point of interest, and composition.

Generally the three concepts that are in play in framing ratios and in the position of main subjects in the image are as follows:

1. Golden Ratio *(Figure 2-6)*, 2. Golden Points *(Figure 2-7)*, and 3. The rule of thirds *(Figure 2-8)*.

Fig 2-6. Golden Ratio **Fig 2-7.** Golden Point **Fig 2-8.** The Rule of Thirds

GOLDEN RATIO

FIG 2-6. Golden Ratio

One of the most used ratios, taken from nature, that creates a desirable balance in the images is called *Golden Ratio*. Typically speaking, this ratio is satisfying to the eyes. Rectangles or squares, which are created using the golden ration, consist of the proportions found in *Figure 2-9*.

The lighter-gray, golden ratio rectangle that has two sides *a* and *b* when placed adjacent to the square with side *a*, will create a similar golden ratio rectangle with sides *a+b* and *a* *(Figure 2-9)*.

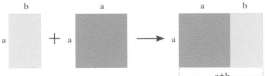

FIG 2-9. Golden Ratio: a+b is to a as a to b

The following example is a rendering that is framed based on this ratio *(Figure 2-10)*.

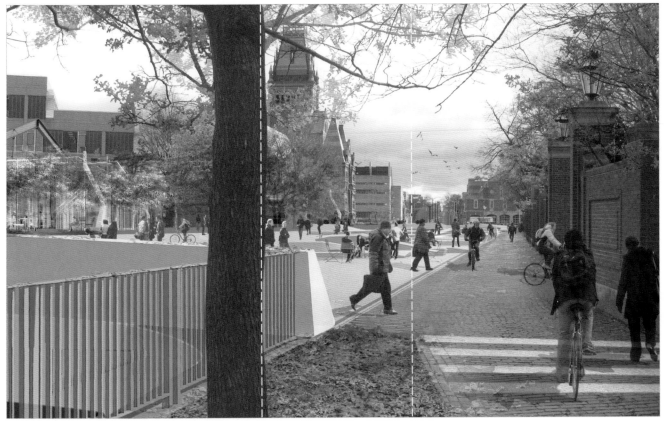

FIG 2-10. The Plaza at Harvard University, MA, USA
Digital media, 11 x 17 in
Illustrated by Shima Rabiee; Copyright to Stoss Landscape Urbanism

PLACEMENT

GOLDEN POINT

FIG 2-7. Golden Point

The placements used within an image that are most appealing to the naked eye is called *Golden Point*. As pointed out at the introduction, there are many shapes in nature which are formed according to this same ratio. The golden point is used in visualization to create a point of interest and a desirable composition and/or to communicate the design point in a more straightforward manner (*Figure 2-7 and 2-11*). Please note that in rotating or flipping the image, four golden points can be found on said rectangle which are resulted from the same ratio (*Figure 2-11*).

It is worth pointing out that these four points' extent of interest is not equal. Experience shows that the most appealing ones are A, B, C, and D which, in this order, provide the observer with the sense of comfort and pleasure. Hence, following this order in setting the composition and placing the design in an image is recommended (*Figure 2-12*).

FIG 2-11. Golden Points

FIG 2-12. The Plaza at Harvard University MA, USA
Digital media, 11 x 17 in
Illustrated by Shima Rabiee; Copyright to Stoss Landscape Urbanism

THE RULE OF THIRDS

FIG 2-8. The Rule of Thirds

There is also another principle for placing the subject within an image, called *The Rule of Thirds*. If you divide a square or rectangular image into three equal parts from length to width, the 1/3 and 2/3 are axes of the image which attract the most attention *(Figure 2-8)*. Therefore, it is recommended to set the composition and designed aspect of a drawing within and/or along one of the dividing lines, located either in 1/3 or 2/3 of an image. This rule, despite disarranging symmetry, creates a sense of visual balance in the image and encourages the movement of the eye *(Figure 2-13)*.

FIG 2-13. Operation Chamartin, Madrid, Spain. (Studio project at PennDesign, University of Pennsylvania)
Digital media, 11 x 17 in
Illustrated by Shima Rabiee

SCALE

Scale is synonymous with dimension and measure: it is the size of the elements within a presented frame which have consistent dimensions and/or proportions to one another. The scale is important in visualization, because it helps provide the necessary and sufficient amount of information from the image as well as avoid excess, unnecessary details. It also helps the viewer comprehend the target of the image better and faster. The extent of the visible details of the image's target and the extent of the visibility of the target's surrounding environment is determined by scale.

If you move the frame further from the scene or closer to it, you can control the number of objects, the extent of their visibility, and their size in the image. If you are drawing a sketch outside and you are using a viewfinder, you can experience this by changing the distance of the viewfinder to the scene. If working in a 3D computer environment, the screen represents the image frame and you control the placement of objects within it and their proportions to each other by zooming in and out *(Figure 2-14)*.

FIG 2-14. Scale study through viewfinder
Pen on paper, 5 1/2 x 8 in
Illustrated by Shima Rabiee

In choosing the proper scale in visualization, we should consider the following principles:
- **Foreground, Midground, and Background:**
In order to introduce the scale of the target in visualization, its location in space and its distance to the viewers, the depth of field is usually divided into three zones: foreground, midground, and background. The foreground is a part of the scene which is closest to the camera and is meant to introduce the scale of the target and its distance to the viewer. The target is usually shown in the midground and everything behind

it, which introduces the context of the image and provides an accurate sense of the atmosphere, is called the background. Look at the following image, which gives you a better sense of these divisions *(Figure 2-16)*.

Note that the ratio of the midground to the entire page is also important. Analyses of artworks show that the best ratio of the midground to the entire image is approximately 1:3 to 1:4 so that the image can provide enough information about the target, satisfy the viewer's curiosity, and create an interesting composition on the page simultaneously *(Diagram B in Figure 2-15)*.

FIG 2-15. Study on the ratio of midground in the image (Diagrams A, B, and C)

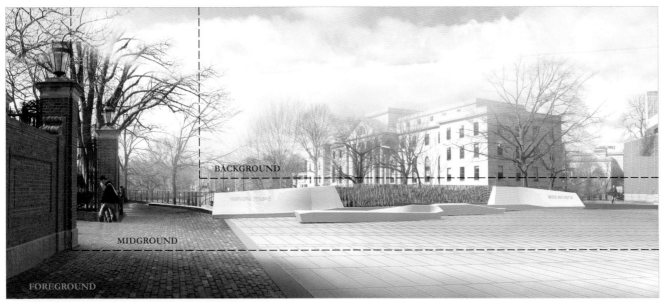

FIG 2-16. The ratio of foreground, midground, and background
The Plaza at Harvard University, MA, USA. Digital media, 11 x 17 in
Illustrated by Shima Rabiee, Copyright to Stoss Landscape Urbanism

• **The scale of the target:**

Our distance from the scene enables us to choose with what precision we see the objects, their details, and understand their relationship to the context. The closer we get to the objects, the bigger they appear and the more discoverable their details become, but for that, regarding the limitedness of our view cone, it becomes more difficult for us to perceive the relation of these objects to their surroundings. The reverse is also true: the more distanced we are from the objects, the smaller we view them and the less number of details we perceive from them, but instead we better understand their relation to their surroundings and their location in space. With regard to this principle, it can be said that the purpose of visualization is a function of the distance from the viewer to the object or the scene.

Therefore, in presenting urban spaces, given that the relation between objects is more important than the objects themselves, they are most frequently viewed from faraway distances, mostly from the bird's-eye-view. On the other hand, in architectural and interior design illustration, the viewer is closer to the scene, because it is more important to perceive the objects and their details rather than their relationship to the environment.

To better understand this principle, look at the diagrams in *Figure 2-17*. As explained in *Time Saver Standards for landscape Architecture* [2], the diagrams demonstrate that the distance of an object from the viewer is directly related to how we view that object and its surrounding environment.

• When our distance from an object equals the height of that object, the object is difficult to see as a whole, but detail can be seen *(Diagram A)*.

• When our distance from an object is twice as big as that object's height, the object can be seen as a unit *(Diagram B)*.

• When our distance from an object is three times as big as that object's height, the object is dominant in visual field, but is seen in relation to other objects *(Diagram C)*.

• When our distance from an object is four times or beyond that proportion as big as that object's height, the object becomes one element of the general scene unless distinctive features make it stand out *(Diagram D)*.

2. Harris, Charles W. and Dines, Nicholas T. *Time-Saver Standards for Landscape Architecture*, 2nd edition. New York: McGraw-Hill Education, 1997.

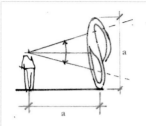

Diagram A: Object is difficult to see as a whole, but detail can be seen

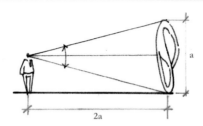

Diagram B: Object can be seen as a unit

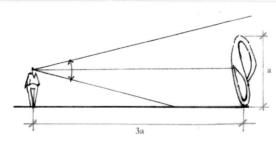

Diagram C: Object is dominant in visual field, but is seen in relation to other objects

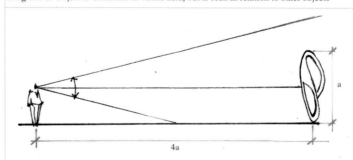

Diagram D: Beyond this proportion, an object becomes one element of the general scene unless distinctive features make it stand out

F**IG** 2-17. Study on the scale of the target (diagrams A, B, C, and D). Pen on paper, 11 x 17 in
Re-illustrated by Shima Rabiee. Diagrams and descriptions taken from *Time-Saver Standards for Landscape Architecture*

DYNAMIC AND ENERGY

The eye always seeks to discover differences or exciting points in an image. A monotonous and balanced image is less appealing/attractive and provokes less curiosity than an image with more points of difference and less balance and homogeneity. Artists use this break up of the monotonous visual balance in the image in order to provoke more curiosity and excitement and to encourage the eye to more dynamism and movement in the image (*Figure 2-18 and 2-19*).

The form of object/space, our location and angle in the space and our distance to the object/space (the field of view), each influences the formation of lines and angles and hence the dynamic or static composition of image to a considerable extent. In general, the more diagonal lines, sharp angles, and large gestures there are in the spatial composition, the more attractive and exciting the image will get. The overall factors which generate dynamism in the image include:

• **The viewer's position to the object:**
The more asymmetric the view angle is, the more dynamic the image gets.

• **The field of view and viewer's distance to the image:**
The closer we are to the target and the wider our field of view (the wider the image lens) is, the more dynamic the image gets.

• **The form of object or space:**
The more diagonal lines and sharp angles the form of the object or space possesses, the more dynamic the image gets.

To better understand these factors, look at the following diagrams in *Figure 2-20*.

FIG **2-18.** Stanford University, McMurtry Building
7 1/2 x 12 1/2 in
Photography by Shima Rabiee

FIG **2-19.** Study of dynamic and energy
Pen and marker on paper, 11 x 17 in
Illustrated by Shima Rabiee

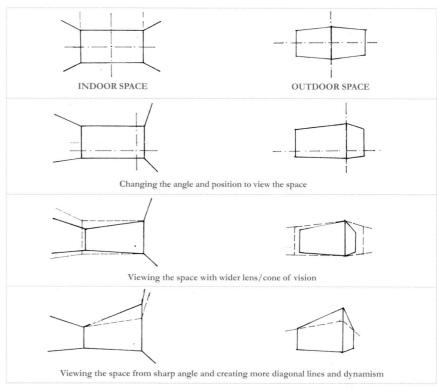

INDOOR SPACE OUTDOOR SPACE

Changing the angle and position to view the space

Viewing the space with wider lens/cone of vision

Viewing the space from sharp angle and creating more diagonal lines and dynamism

Fig 2-20. The effective factors on dynamics and energy. Pen on paper, 8.1/2 x 11 in. Illustrated by Shima Rabiee

The two following drawings, *Figure 2-21 and 2-22,* are examples of illustrating a building with and without effective dynamic. Compare the two images to better understand the role of dynamic and energy in representing an object or space in the design visualization.

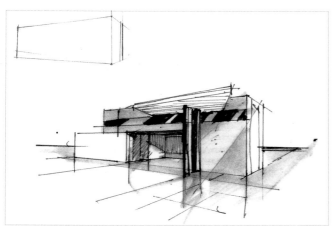

Fig 2-21. Perspective drawing I (regular view to the building)
Pen and marker on paper, 8 1/2 x 11 in
Illustrated by Shima Rabiee

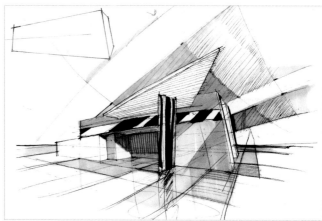

Fig 2-22. Perspective drawing II (view with dynamic and energy)
Pen and marker on paper, 8 1/2 x 11 in
Illustrated by Shima Rabiee

NEGATIVE AND POSITIVE

In a two-dimensional image, the part where the object is situated is called *Positive* space, and the part which is empty of objects is called *Negative* space.

The following points should be considered regarding negative and positive spaces:

• **Negative and positive spaces complement one another:**

It is sometimes falsely believed that only the positive space is important because it is an image's target, and the existence of the negative space in an image is of little significance, while in fact, it is the negative space which facilitates a better understanding of the form of the positive space, differentiates the object from the surrounding area, enhances the composition, and creates direction and movement toward the target point. Refer to *Franz Kline's* beautiful drawing, *Figure 2-23*, and *Figure 2-24*, to better understand this discussion.

• **The ratio of positive and negative spaces matters:**

The ratio of negative and positive spaces is very important. As mentioned in the scale section in *Figure 2-17*, the viewer's distance to the target should be at least three times as much as the proportion of the target, so that the viewer can completely understand the overall form of the target and see some of the context or negative space of the image. A smaller distance than the amount mentioned leads to the omission of the negative space. As a result, the viewer will gaze at the details of the target and will not completely comprehend the overall form, structure, and composition.

Naturally, the negative space occupies between 1:2 to 1:3 of the entire image. But these ratios can vary depending on the purpose or subject of the image. Besides having aesthetic value, different ratios of positive and negative spaces induce different meanings of the target of the image. Hence, considering the ratios of positive and negative spaces to the entire image is of great importance (*Figure 2-25* and *2-26*).

Sometimes the border between positive and negative spaces is not clear. Like *Figure 2-27*, in which negative spaces are shown with black and positive spaces with the white,

FIG 2-23. Untitled (1960). Brush and ink on paper, Sheet (irregular): 8 5/16 × 10 13/16 in. Franz Kline (1910-1962)
Whitney Museum of American Art, New York; Purchase, with funds from Mr. and Mrs. Benjamin Weiss 78.53

FIG 2-24. Study of negative and positive space
Pen and marker on paper, 8 1/2 × 11 in
Illustrated by Shima Rabiee

whereas the border between them is marked with the color gray. Whether there is a distinct border between the positive and the negative spaces or not, their ratios to one another should always be carefully considered.

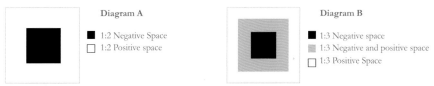

Diagram A

■ 1:2 Negative Space
□ 1:2 Positive space

Diagram B

■ 1:3 Negative space
▨ 1:3 Negative and positive space
□ 1:3 Positive Space

FIG 2-25. The approximate ratio of negative and positive space (Diagrams A and B)

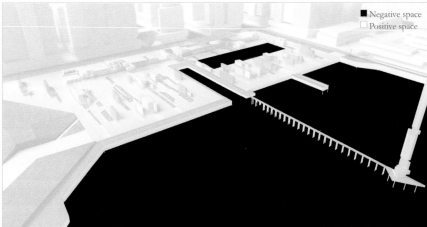

■ Negative space
□ Positive space

FIG 2-26. Culture Village Waterfront Development (phase two), Dubai, UAE
Digital media, 17 x 24 in
Illustrated by Shima Rabiee, Copyright to SWA Group

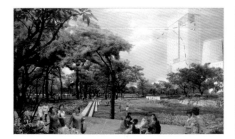

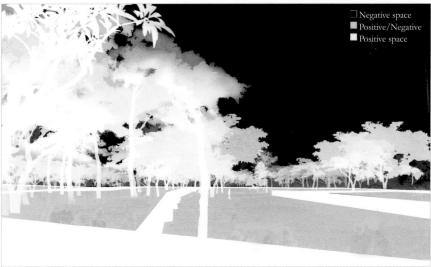

□ Negative space
▨ Positive/Negative
■ Positive space

FIG 2-27. Huangpu Riverfront, Shanghai, China.
Digital media, 11 x 17 in
Illustrated by Shima Rabiee, Copyright to Stoss Landscape Urbanism

COLOR

DIMENSIONS OF COLOR

Color is among the factors which, besides demonstrating the physical specification of objects and creating a sensual impression of space, can be effective in controlling values and composition, as well as in strengthening the three-dimensional sense of a space.

• **Dimensions of Color:**

To introduce color, we should first introduce the concepts of hue, saturation, and value which are the defining components of color.

Hue

Hue means the color itself, like yellow, blue, red, green, orange, purple, etc. and any other color which is the result of mixing different portions of these colors—such as blue-green, light green which tends towards yellow, olive green, etc. Therefore, according to this definition and as it can be seen in the diagram below, there is an infinite number of colors or hues *(Figure 2-28)*.

FIG 2-28. Hue

Value

Value is the degree of the color's lightness or darkness, which is determined based on the extent of the mixture of the color in question with white or black. For example, the following diagrams show different values of green *(Figure 2-29)*.

FIG 2-29. Values of green

Saturation

Saturation is the extent of brilliance or dullness of a color. The percentage of the mixture of the color in question with the color gray, which can vary between 0 to 100 percent, determines the color's saturation. To better understand the concept of saturation, the color green is shown with different saturation degrees in the following diagram *(Figure 2-30)*.

FIG 2-30. Saturation of green

VALUES OF COLOR

Now that you have developed a basic familiarity with the concept of color, note the following points, which explain the effective use of color to express the form and space, using two examples in the next page *(Figure 2-34 and 2-35).*

- **Colors too have value:**

Note that all of the color dimensions, which were introduced as hue, value, and saturation, have a certain value. For example, look at the values of colors in the following tables and compare them to each other.

Regarding the hue of the colors, note that yellow has the highest and purple has the lowest value, and all other colors between them are grays with different values *(Figure 2-31).*

FIG 2-31. Value scale of colors

Regarding the value of the colors, note that the more white there is in the color, the higher its value. In the same way, the more black there is in it, the lower its value *(Figure 2-32).*

FIG 2-32. Value scale of green

Regarding the saturation of the colors, note that the higher the saturation of the color, the higher its value and the lower the saturation of the color, the lower its value *(Figure 2-33).*

FIG 2-33. Saturation scale of green

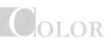

COLOR

EXPRESSION OF FORM AND SPACE

- **Colors should complement and reinforce the value and contrast of an image, so that they contribute to a more effective presentation of the three-dimensionality of the volumes and the space:**

Note that, as mentioned in this section, colors have a value which can be raised or lowered by changing the color dimension, the hue, value, and saturation. If our choice of color corresponds to the value and the contrast of the image, it presents the three-dimensional form and space more effectively and expressively. The contrast between the blackness and whiteness existing in the image—which is the result of the light and shadow of the objects, their position in the space or the composition of the image—can be reinforced by color and thereby present the three-dimensionality of form and space in a more expressive way.

For example, in *Figure 2-34*, yellow has been used in the light spot of the image and the blue-green in the background. These two colors are complementary colors which have almost the greatest value difference with each other, and therefore the form of the anatomy of the body tends to advance in the space and appears more expressively. In contrast, the color purple seems to recede in the space.

In *Figure 2-35*, the orange color of the path against the blue and green background has caused this value difference, which in turn presents the form of the path more clearly and as close to the viewer as the foreground.

Besides hue, the value of the color should also change according to lights and shadows, darkness and lightness and the contrast of the image. The higher the contrast is, the greater the difference of color values gets. For example, look at the yellow in *Figure 2-34* and the different degrees of its value in point *A* and *B*, and how their value changes based on shadow and light. Also take a look at *Figure 2-35*, and compare the extent of

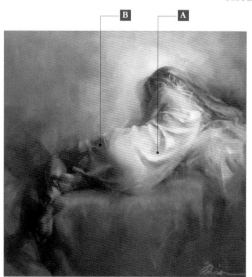

FIG 2-34. Portrait study
Oil paint on panel, 18 x 20 in
Painted by Shima Rabiee

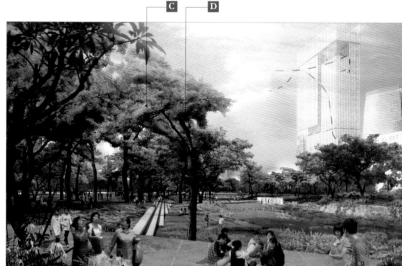

FIG 2-35. Huangpu Riverfront, Shanghai, China
Digital media, 11 x 17 in
Illustrated by Shima Rabiee, Copyright to Stoss Landscape Urbanism

COLOR TEMPERATURE AND EXPRESSION OF DEPTH

value changes of the green color on the trees. The green color in point *C*, where the light hits the top of the canopy, has the highest value and in point *D*, where there is shadow in the bottom of canopy, has the lowest value.

In the same way, by changing the intensity of saturation, it is also possible to enhance the contrast and composition of *Figure 2-35*. In spots which are more intensely lit, the color is presented with a higher saturation, and in spots which are less important, it is presented more neutrally and with less saturation.

- **Color temperature and the concept of depth:**

Warm colors such as yellow, orange, red and light green are more manifested and seem closer, whereas cool colors like blue, violet and blue-green create less gaze and seem farther away. Therefore, choosing warm colors for the image's foreground and cool colors for the background, enhances the sense of depth of space. In the following example, *Figure 2-36*, the color of the floor is a cool gray and the color of the buildings is a warm yellow. If the temperature of these two colors is modified according to their distance to the viewer in space, meaning that we make the color of the building cooler and the color of the floor warmer, the three-dimensional sense and the depth of the space can be demonstrated better. Refer to *before* and *after* images in *Figure 2-36* to better understand this discussion.

- **Colors are also influenced by their environment and surrounding colors:**

This point is elaborated in the following discussion about harmony.

Note that color temperature and value are all relative and can not be precisely introduced or measured for their use. For example, if a neutral gray is placed besides a warm color, it will appear as a cool gray, and if it is placed besides a cool color, it will be perceived as a warm gray. Hence, it is very important to know that color's temperature and their values are relative, not constant.

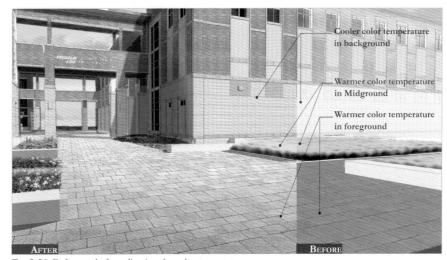

FIG 2-36. Before and after adjusting the color temperature
Texas A&M University, TX, USA. Digital media, 11 x 17 in
Illustrated by Shima Rabiee, Copyright to SWA Group

HARMONY

Harmony means leveling the technique, color, and complexity of an image. In an image with a correct harmony, everything makes sense. All the points in the image have the same value and visual weight. The eye does not get stuck on a certain point; instead, it constantly moves across the page, searching for points of difference.

The harmony consideration is crucial in visualization, because it enables a better understanding of composition and spatial relations through reducing unnecessary viewpoints; and therefore, it facilitates the comprehension of target objects and the overall space in the image.

The important consideration in homogenizing harmony in visualization is creating cohesion and coherence in an image in a way that in the end, a sense of unity is achieved in the entire image. Sometimes, when reviewing a rendered image, it seems that although all the elements of the image follow the same rules, principles of perspective, color, composition, proportion, placement, tone, light, and shadow, they do not seem to belong to one space or complex. The reason for this could be a lack of coherency in either the color harmony or in the extent of detail, and complexity of the image. See *Figure 2-37* for coherency in color harmony.

Below we review these two factors that affect the harmony of the image in more depth:
- **The details harmony:**

To achieve the homogenous image we should unify the extent of details, texture and complexity in all points of the image, so that the visual weight is balanced and equal everywhere.
- **The colors harmony:**

Here we review the colors' hue, value, and intensity and we make changes, if necessary, to the overall color value and temperature in order to contribute to the unity of the image and reduce unnecessary distraction. In this process we should keep in mind the two following notes:

 - Reducing viewpoints and varieties in colors' saturation and value:

 We reduce the colors' intensity and varieties in the image to prevent gaze and to enable the viewer to comprehend the overall space easier with less distraction.

 - The colors are affected by the environment:

 The source of light, time of day, season, and the space's geographical location, all influences the temperature of the image's colors. Therefore, the extent of the color's warmness or coolness (color temperature), lightness or darkness (value), dullness or brilliance (saturation), should be all revised and unified, as they are influenced by the same environment.

- The colors are also affected by their surrounding color:

The intensity, the value, and temperature of colors are also influenced by their surrounding color. Given that light and shadows, darkness and lightness, etc. influence the entire space, the colors in space are usually in one and the same circumstance. Where the intensity of light and therefore saturation are high, all the colors adjacent to the light spot have high saturation. On the contrary, points in the depth of the image which are situated in the dark, have colors with lower values. Refer to *before* and *after* images in *Figure 2-37* to better understand this discussion.

- Color temperature and the concept of depth:

As we explained in the *Color* section, warm colors tend to move forward in a space and cool colors tend to recede. Therefore, in visualization, we may increase and exaggerate the difference of color temperature, to create more depth in the space and communicate the three-dimensionality of its spatial structure.

Before adjusting color harmony

After adjusting color harmony

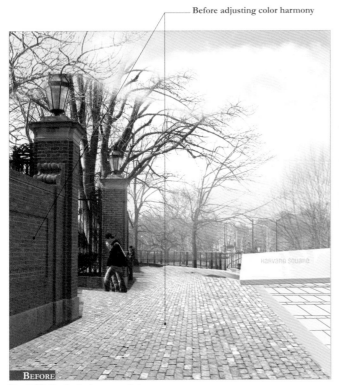

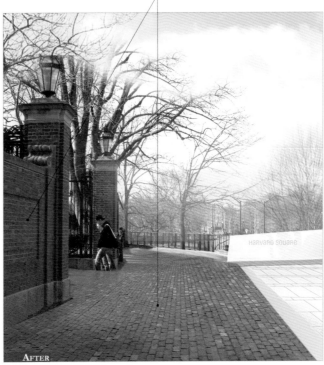

FIG 2-37. Study the harmony balance
The Plaza at Harvard University, MA, USA
Digital media, 11 x 17 in
Illustrated by Shima Rabiee, Copyright to Stoss Landscape Urbanism

CONTRAST

EXPRESSION OF FORM

The extent of lightness or darkness in an image is called *Contrast*. Contrast is usually determined based on the type of the light source, its intensity and its distance from the object. The closer and more intense the light source, the greater the difference between the blackness and whiteness of surfaces, and therefore the higher the image's contrast. The highest contrast belongs to an image in which only the colors white and black are used. If the color gray is also used, the image's contrast decreases. The bigger the number of gray tones between black and white gets, the lower the contrast will sink. Refer to *Figure 2-38* to better understand the concept of low, medium, and high contrast.

Low Contrast Medium Contrast High Contrast

FIG 2-38. Contrast study

- **Contrast can expressively introduce the three-dimensionality of volumes and their relation to the space or to each other:**

Light helps us understand the difference between surfaces easier, and facilitates the conception of the three-dimensionality of space and its relations. The more intense the light is, the higher the contrast and therefore it is easier to distinguish the form, composition, and spatial relations in the space (*Figures 2-39* and *2-40*).

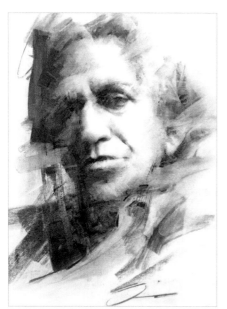

FIG 2-39. Portrait drawing (Contrast study 1)
Charcoal on Bristol paper, 18 x 20 in
Illustrated by Shima Rabiee
Photo credit to Patrick Demarchelier

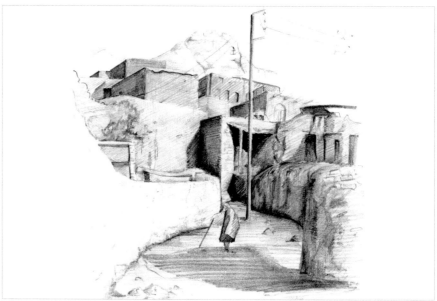

FIG 2-40. Drawing from Abyaneh village
Pencil on paper, 8 1/2 x 11 in
Illustrated by Shima Rabiee

EXPRESSION OF MOOD

- **The intensity of contrast introduces the mood and character of the space:** Besides revealing the three-dimensionality of volumes and spatial relations, contrast can also introduce the mood and influence our perception of the spirit and character of space.

For example, compare the two images, on page 75, *Figures 2-39* and *2-40,* and two images on this page, *Figure 2-41* and *2-42. Figure 2-41* and *2-42,* which are composed of the colors black and white, have more contrast as compared to *Figure 2-39* and *2-40,* which possess a wide range of gray tones as well. The higher contrast images on this page communicate the feelings of mysteriousness, darkness and fear, whereas the lower contrast images on previous page, express a friendlier, brighter, and more peaceful feeling/environment.

Therefore, as you see, the choice of the intensity of contrast also influences the introduction of the mood and character of the image/space and therefore it should be taken into consideration in visualization process.

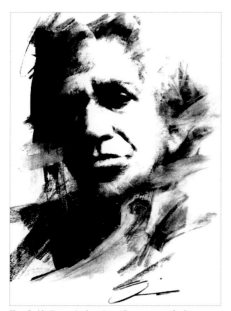

FIG 2-41. Portrait drawing (Contrast study 2)
Charcoal on Bristol paper, 18 x 20 in
Illustrated by Shima Rabiee
Photo credit to Patrick Demarchelier

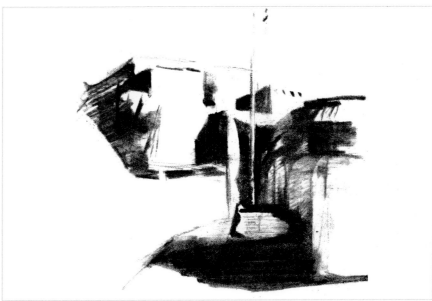

FIG 2-42. Drawing from Abyaneh village
Charcoal on Bristol paper, 8 1/2 x 11 in
Illustrated by Shima Rabiee

FOCAL POINT

The point or area in the image which is the most interesting and appealing to the viewer's eye and have the most emphasis in the image is called *Focal Point* or *Point of Interest*. This point is presented differently from the other points of the image. It has a higher contrast or intensity in tone and color and presents more details of the space or of the objects, in order to attract more attention. Point of interest is usually used for easier communication to the point of the drawing, or simply in order to create more visual interest, excitement, movement, and enhanced composition (*Figure 2-43* and *2-44*).

The placement of focal point on the page is not randomly chosen, or chosen for mere aesthetic reasons. It is also not easy to specify it, because the reason for implementing it could be one or several of the following:

- **Revealing the form of the object or the space better.**
- **Creating the sense of distance and a more intense sense of three-dimensionality in space:**

Closer points include more details to advance in the images and further points have less detail to recede in the space.

- **Attracting the viewer's attention to a certain target or concept.**

Sometimes the entire image is drawn in an abstract manner with the less amount of details, whereas the target point is presented with an acceptable amount of details, so that more attention is paid to it. For quicker and more effective communication, sometimes not only do we give the image's target more detail, contrast, and intensity of color, but we also leave the other parts of the image unattended (*Figure 2-43*).

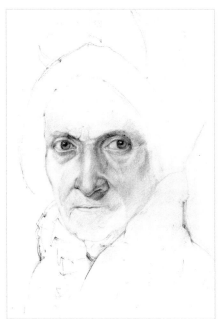

FIG 2-43. Portrait study
Pencil on paper, 8 x 11 in
Illustrated by Shima Rabiee

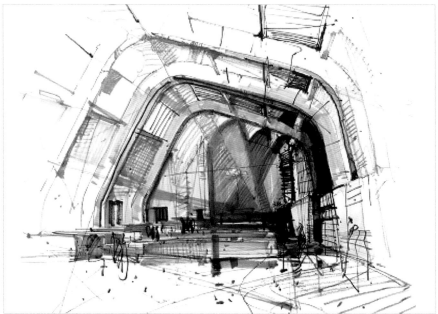

FIG 2-44. Study of tone and composition 1
Pen and marker on paper, 11 x 17 in
Collaborative work with students at freehand drawing workshops

- **Creating a better composition.**
- **Causing gaze or movement of the eye on the page:**

In digital illustration, we create this effect by increasing the intensity of colors, texture or light. Look at the following examples, *Figure 2-45* and *2-46*; In the point of focus, the light is more intense and the colors of materials are richer. Notice that the location of this point of focus should correspond to the image's overall language of light and shadow. Light spots become lighter and darker ones become darker. In a spot where colors are dull due to the distance of objects, colors become duller and in spots which are closer to the viewer, they are presented more brilliantly and extensively.

Increased value and intensity of colors at focal point

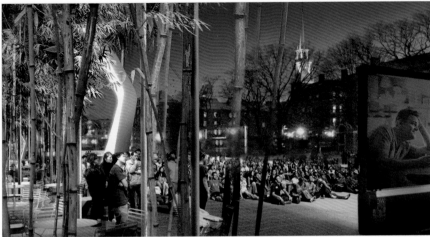

Fig 2-45. The Plaza at Harvard University, MA, USA
Digital media, 11 x 17 in
Illustrated by Shima Rabiee, Copyright to Stoss Landscape Urbanism

Increased value and intensity of colors at focal point

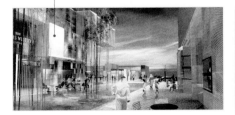

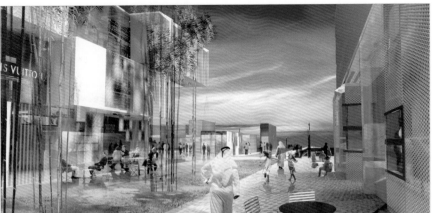

Fig 2-46. Culture Village Waterfront Development (phase two), Dubai, UAE
Digital media, 17 x 24 in
Illustrated by Shima Rabiee, Copyright to SWA Group

COMPOSITIONAL GESTURE

A good sketch or work of art usually does not consist of a single and independent object on the page, but it rather includes multiple objects or shapes which are composed next to each other based on the designer's purpose or at the service of a certain composition. This collection of objects, depending on their form, position, and combination or based on their composition on the page, create angles and lines which attract the viewer's attention. As previously noted, since the eye looks for outstanding and exciting points in the image, the intensity of the attraction and attention of the eye vary based on the composition of these lines and angles. Horizontal movements move the eye horizontally and vertical, diagonal or curved lines control the movement of the eye along their respective direction. Hence, the composition of geometrical shapes and angles in an image, which is a decisive factor in the dynamic of the image, should be studied and considered in visualization.

Here, it is important to consider two following notes about *Compositional Gesture* in visualization:

- **A thorough recognition of the primary composition of the image based on line gestures and angles:**

In each image, we should first thoroughly analyze the primary composition of the image based on the lines and angles of its elements by drawing it as a simple sketch. When performing this analysis, note that in presenting a live or photographed image in an abstract way, we should ignore the details and only pay attention to the overall geometry. If we keep our eyes half-open and try to view the image in a more abstract way, we can recognize the shape of the forms and the determining axes more easily. The importance of these shapes is due to their considerable influence on the final dynamic and composition of the image.

To better understand this discussion, look at the following examples, *Figure 2-47* and *2-48,* which represent the compositional gestures of the images.

FIG 2-47. Gestural lines of still-life objects
Pencil on paper, 18 x 20 in
Illustration by Shima Rabiee

FIG 2-48. North Bund White Magnolia Plaza, Shanghai, China
Digital media, 11 x 17 in
Illustration by Shima Rabiee, Copyright to SWA Group

• Prioritizing and emphasizing more important gestures:

As stated before, when forming the image composition, there are sometimes one or more important gestures which are, due to their properties, boldly present and highly important in introducing space. In such cases, the artist or designer should decide, which of the shapes/lines is more significant in communicating the point of the image and the abstract of the space. After making this decision, the artist intensifies that gesture—using tone, contrast, color, details, etc.—and thus leads the viewer's attention to it. In the same way, some of the lines and shapes which exist in the composition but do not play a significant role, are toned down or omitted.

Look at the following drawing, *Figure 2-49*, as an example. This drawing of the city has several shapes and lines: the horizontal line that introduces the bridge, the vertical and diagonal lines in background that represent high-rise buildings and the diagonal line in foreground that defines the edge of the river. As the bridge become the main subject of the image, more emphasis and contrast is put on the horizontal gesture using tone and further details to express its form better.

Fig 2-49. Compositional gesture
Sketch from Schuylkill River, Philadelphia, USA. Pencil on paper, 18 x 20 in
Illustrated by Shima Rabiee

SPATIAL STRUCTURE

Spatial Structure is a set of lines, shapes, tones and colors, the combination of which demonstrates the overall structure of a space or an object in the simplest and most expressive way. This structure comprises basic information which plays the most significant role in the formation and understanding of a space. Eliminating this information from or leaving them incomplete in the image makes understanding the basic characteristics of the object or the space troublesome. These elements, although seem very basic, they carry most of the image's highly important information and should be drawn with great care and attention and with respect to all perspective principles, so that they can communicate all the physical, sensual and conceptual properties of the space or the object.

For example, look at the following portrait, *Figure 2-50*, which was drawn by *Zhaoming Wu*, who has communicated the concept of his portrait subject comprehensively and beautifully at this stage through spatial structure. Although the drawing is yet unfinished, it seems complete to the extent that not only the form and shape of the face, but also its expression and emotions are comprehensible. This stage of drawing/painting is so interesting, beautiful, adequate, and satisfying to the viewer that artists sometimes decide to leave the work at this stage and consider it finished. This very well introduces the role and importance of the spacial structure in visualization. The spatial structure comprises a set of information which, although limited and general, is at the same time necessary, useful and adequate for the users. It satisfies the viewers' sense of curiosity, so that they do not feel the necessity for seeing more details and information in the image *(Figure 2-51)*.

Fig 2-50. Portrait drawing, charcoal on paper, 18 x 20 in
Zhaoming Wu (1955 - Chinese)
Academy of Art University, San Francisco

Fig 2-51. The campus corridor. Pen and marker on vellum paper, 11 x 17 in
Illustrated by Shima Rabiee

- **Spatial structure in freehand drawing:**

Generally, and especially in free-hand presentation, we should take considerable care, given that spatial structure elements are the main elements and skeleton of the image, they be drawn with precision, clarity, and assuredness, because the next details and elements of space will be developed from the same base, view, scale, horizon line, and possibly vanishing point(s). Also, given that these elements present a summary of the space, they determine and consolidate the viewer's conception of space. Therefore, it is mandatory that they be distinguished and executed correctly.

In general the structure of an object or space are defined in three steps/categories *(Figure 2-52)*:

1. Gestural structure:

A set of quick lines, shapes, and gestures which carry the primary composition, movement and dynamics of the image, and define the form of the objects/space in the simplest way.

2. Spatial Structure:

A set of elements,—lines shapes, tone and colors—the combination of which demonstrates the structure of a space or an object in the most abstract, comprehensive, and expressive way. These elements carry all the critical info of the three-dimensional forms, structures, movements, and dynamics, and therefore, they require a careful and subtle observation. The spatial structures are the most critical and fundamental elements of the drawing and visualization and they are the focus of this discussion

3. Complementary structure:

A set of supplementary elements which add more information to the object or space and make it more real. This set of information follows the basics and principles of the spatial structure and their view points, dimensions and proportions, perspective, colors,

1. Gestural Structure

2. Spatial Structure

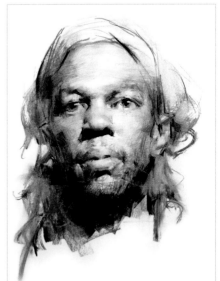

3. Complementary Structure

Fig 2-52. Three steps of drawing a portrait. Charcoal on paper, 18 x 20 in
Zhaoming Wu (1955 - Chinese)
Academy of Art University, San Francisco

etc. match the basics and principles of the spatial structure. Providing information of this type in the visualization is not necessary, but it can be helpful. Drawing these supplementary elements does not require too much care and attention, because the framework of the image was already formed by the spatial structure.

- **Spatial structure in digital visualization:**

Sometimes it is believed that the consideration and application of spatial structure is only necessary in freehand drawing and not in digital presentation; while in fact, these lines should be more well communicated in the complex digital presentations. Although these lines are not directly present in digital renderings, distinguishing them in the rendering is very important, as it allows us to consolidate this structure and offer the viewer a more clear understanding of their presence, as we develop the image and add more details to it. It is very important to let the detail contribute to the understanding of the space through these structures, and not distract the comprehensive understanding of it. Any stroke of the pen, color, addition or elimination of elements and materials, etc. in either digital or freehand drawing is only then recommended in visualization, when it reinforces the spatial structure and makes it stand out. Applying any change which causes distraction and weakens the spatial structure's visibility is not recommended.

For example, take a look at the three following images in *Figure 2-53*, which demonstrate the three above-mentioned steps: gestural structure, spatial structure, and complementary structure, in digital visualization. In step two, we highlight the spatial structure of the image, and offer a better understanding of its presence in the space. In this step, in order to represent the pedestrian path—which is the main element of the spatial structure of the image—and make it stand out, the following elements have been used:

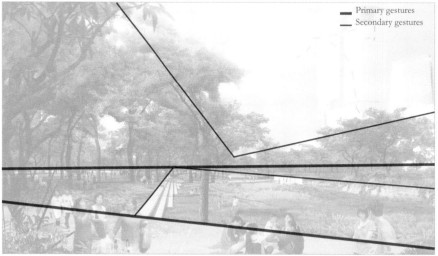

Primary gestures
Secondary gestures

1. Gestural Structure

A. Complementary colors have been used for the path and its background so that the pedestrian path gets the highest contrast and visibility.

B. Tone variation along the edge of the path creates three-dimensional illusion and makes the pathway stand out better.

C. The active and massive presence of human figures has been shown along this pathway, in order to constantly lead the eyes towards the path and emphasize its importance.

D. The placement of trees, as highlighted vertical elements at the edge of the path, plays a critical role in defining the pathway and putting more emphasis on its form and movement from the image's foreground to its background.

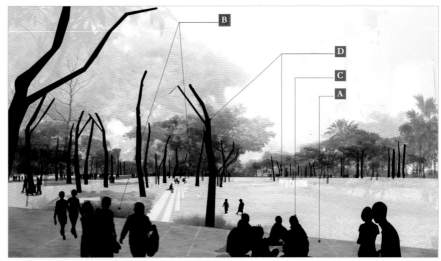

2. Spatial Structure

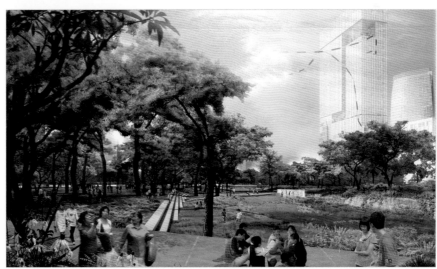

3. Complementary Structure

FIG 2-53. Three steps of representing the structure of a space
Huangpu Riverfront, Shanghai, China. Digital media, 11 x 17 in
Illustrated by Shima Rabiee, Copyright to Stoss Landscape Urbanism

GROUPING AND DIRECTION

The continuity of similar elements in a specific direction creates a sense of movement and leads the eyes towards that direction. The more similar the elements are, the more driving the direction gets for the eye, and the less similar and homogeneous they are, the less tendency the eye has to look towards them [3] *(Figure 2-54)*.

Look at the following example, *Figure 2-55*, which shows a series of similar birds which move in the same direction. Their position on the page inevitably directs the eye across the page.

Note that if these birds were not similar and of the same kind, this extent of attraction and encouragement of the eye to movement would not be the same. This principle is widely used in image development and visualization *(Figure 2-56)*.

FIG 2-54. Diagram of grouping and direction Pen on paper, 2 x 4 in

FIG 2-55. Crows. Early 17th century
Pair of six panel screens; ink and gold on paper. Japanese
Seattle Art Museum. Credit line: Eugene Fuller Memorial Collection. Photographer Seiji Shirono, National Research Institute for Cultural

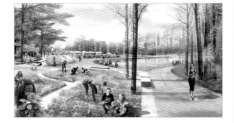

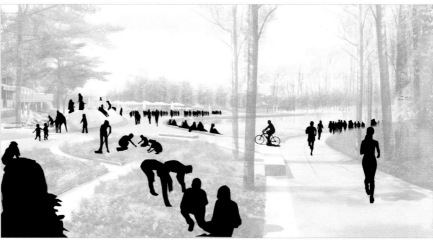

3. Mendelowitz, Daniel M. and Wakeham, Duane A. *A Guide to Drawing*. 5th edition. California: Harcourt Brace Jovanovich College Publishers, 1993.

FIG 2-56. Woodson's Reserve, Texas, USA
Digital media, 17 x 24 in
Illustrated by Shima Rabiee, Copyright to SWA Group

Its importance for illustration is due to the following reasons:

- **It increases the readability of the space:**

Similar elements make the image simpler and hence more legible to read.

- **It creates movement in depth of the image and facilitates its three-dimensional comprehension:**

If similar elements with different scales repeatedly occur on the page, they cause the three-dimensional movement of the eye in the image. If these elements are placed along the three-dimensional structure of the space, they create the impression of depth and better introduce the three-dimensional structure of the drawing in perspective. *Figure 2-57* is an example of the movement of human figures in a certain direction which draws the eye into the image and causes a better understanding of the depth of the space and its three-dimensionality.

- **It better introduces the space's main structure:**

Images usually contain many details and much complexity and comprehending their main concept and structure is not simply possible through perspective. In such cases we can emphasize the primary axes which play a more important role in introducing the design concept. Repeating interconnected and similar elements along these structures not only makes the image more lively and dynamic, it also leads the eye along them and introduces the frame of the design better in perspective.

To better understand this, look at *Figure 2-57* and note how positioning the human figures along a path leads the eye's movement. Using scattered and non-similar elements in illustration, sometimes causes unnecessary distraction and does not contribute to comprehend the concept of the space. Hence, we should be selective in positioning these elements—elements such as human figures, furniture, cars, trees, etc.—to make the visualization more expressive and legible.

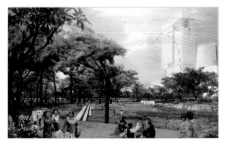

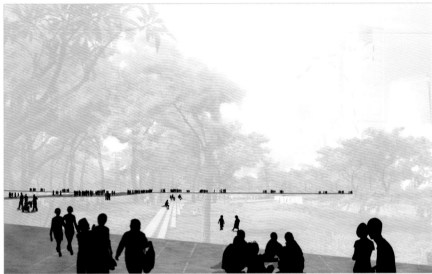

FIG 2-57. Huangpu Riverfront, Shanghai, China
Digital media, 11 x 17 in
Illustrated by Shima Rabiee, Copyright to Stoss Landscape Urbanism

ILLUSION OF DEPTH
VALUE AND SCALE

Creating *Depth* means creating a three-dimensional illusion in a two-dimensional image. This is very important in visualization and communication of the drawing, because many design presentations are carried out using two-dimensional drawing, and hence any factor, like value and color, that can help these drawings be perceived as three-dimensional is highly valuable and worth studying.

Generally, it can be said that depth is created in two-dimensional perspective drawings in the following two ways:

• **Value:**

In the tone section in chapter one, it was comprehensively explained how the drawn shapes can seem closer or farther away and create a sense of three-dimensionality for the viewer by being presented as darker or lighter. Generally, it can be said that in drawings, darker objects are felt to be closer and lighter ones seem further away.

For example, look at the following image, *Figure 2-58*. The six persimmons have the same proportions and seem to be placed at the same location in the image, as they are not drawn in different sizes to comply with the principle of perspective. Nevertheless, due to their varying values, they appear as being placed at different distances. See the application of this principle in creating illusion of depth in visualization in *Figure 2-59*.

• **Scale of repetitive elements:**

Repetitive use of similar elements with different scales gives the sense of differing distances and therefore creates a better sense of three-dimensionality in the image. Note that the elements should be similar so that the eye can link them together and feel

FIG 2-58. Six persimmons
Ink on paper, 14 1/2 x 11 1/4 in
MU-CH'I (13th Century; Chinese)
Ryoko-in, Daitokuji, Kyoto

FIG 2-59. The Plaza at Harvard University, MA, USA
Digital media, 11 x 17 in
Illustrated by Shima Rabiee, Copyright to Stoss Landscape Urbanism

the illusion of depth. If elements such as human figures, trees, furniture and so on are repeated with different scales in rendering, they can create this effect *(Figure 2-60)*.

To better understand this discussion, refer to *Grouping and Direction* in this chapter.

FIG 2-60. Stadium Park Redevelopment, Texas, USA
Digital media, 11 x 17 in
Illustrated by Shima Rabiee; Copyright to SWA Group

VISUAL WEIGHT AND MOVEMENT

A good image is one that constantly plays with the viewer's eyes and moves them across the page to discover its different points. A balanced and monotone image is less attractive and triggers less curiosity than one with more variety. Artists use tone variation as an effective approach for creating dynamism and disarranging visual weight. Tone variations make the eye linger longer on the darker points and move from there to lighter or simpler parts. For effectively controlling the *Visual Weight* of the image and creating movement, it is important to consider the following points:

- **The natural tendency of the eye's movement:**

Research has shown that our eyes frequently tend to move towards a specific direction when looking at an image with equal tone values in all points. For example, the eye is more likely to move from the bottom to the top, and the left to the right than the other way around *(Figure 2-61* and *2-62)*. Therefore, if the image reveals the information in the same direction towards which the eye has a greater tendency, it appears more balanced, pleasant, and beautiful to the eye. Of course there are other opposing opinions about the natural movement of the eye as well, but the main point here is rather the importance of the movement of the eye across the page which is encouraged by differing visual weights of the sides of the page, and not the direction of this movement. The following examples, *Figure 2-63* and *2-64* exemplify this application of tone and visual weight variation from the bottom to the top in the images.

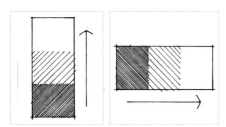

FIG 2-61. Visual weight from the bottom to the top

FIG 2-62. Visual weight from the left to the right

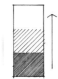

FIG 2-61.

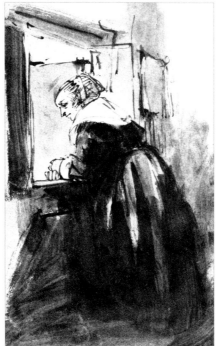

FIG 2-63. Woman looking through window
Rembrandt Van Rijn(1606-1669)
Pen, brush and ink. 6 1/2 x 11 1/2 in
The Louvre Museum

FIG 2-64. Urban sketch
Pen and marker on paper, 8 1/2 x 11 in
Illustrated by Shima Rabiee

Another example of creating movement through visual weight is *Figure 2-65* by *Rembrandt* in which, despite the complexity of the image lines, the artist has cleverly created a center of gravity on the left side of the image using tone, and thereby directs the movement of the eye towards the left side of the image.[4] *Figure 2-66* follows the same rule and, by creating a darker tone on the left, leads the visual weight and the eye's movement from the left to the right side of the image.

- **Gradual vs sudden variation:**

Note that tone variation should be applied gradually so that it encourages the movement of the eye across the image. Sudden, ungradual differences cause gazing at certain points of the image.

- **Effective factors on disarranging visual weight:**

In addition to value changes, disarranging the visual weight and creating movement is also possible through varying the color harmony, extent of detail and texture in some parts of the image more than others.

Fig 2-62.

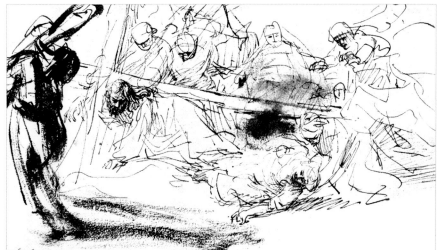

Fig 2-65. Christ Carrying the Cross
Pen and ink with wash, 5 5/8 x 10 1/8 in
Rembrandt (1606-1669; Dutch)
Staatliche Museen Preussischer Kulturbesitz,
Kupferstichkabinett, Berlin

Fig 2-66. Huangpu Riverfront, Shanghai, China
Digital media, 11 x 17 in
Illustrated by Shima Rabiee, Copyright to Stoss

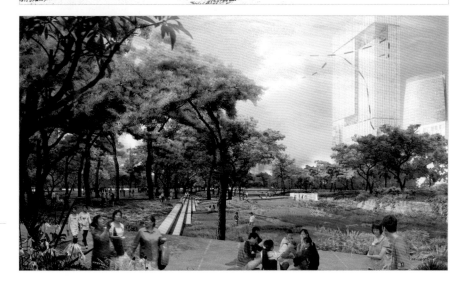

4. Chaet, Bernard. *The Art of Drawing*. 3rd edition. California: Thomson Wadsworth, 1983.

3

cha

Principles and
Process of
Visualization

CHAPTER III:

PRINCIPLES AND PROCESS OF VISUALIZATION

The illustration process, involves different stages and procedures; which means that its development should be undertaken in different layers, with respect to the order of stages and with awareness of the principles, so that the resulting image turns out legible, purposeful, and expressive. Therefore, developing a deep understanding of these principles and using them properly and in the order is of great importance.

This chapter explores the steps for visualizing and developing a space in design studios. With important principles and factors of drawing and representation having been introduced in previous chapters, this chapter describes the application of these principles to visualization and rendering, providing step-by-step examples. These examples include both digital and freehand drawing techniques as well as their combinations. This chapter recommends taking eight following steps for the visualization of space in all techniques:

- **Step 1:** Setting the base
- **Step 2:** Analyzing the form and structure of the space
- **Step 3:** Applying colors and materials
- **Step 4:** Creating harmony and sense of unity
- **Step 5:** Revealing the three-dimensional form through implication of light and shadow
- **Step 6:** Enhancing the compositional structure
- **Step 7:** Expressing depth and spatial quality
- **Step 8:** Creating dynamics, movement, and energy

Understanding and applying these eight stages in visualization, regardless of the visualization technique, makes that visualization highly comprehensible, effective and expressive. In this chapter, we study how these factors can be effective in visualizing process and can contribute to the better understanding and presentation of the design intent.

TECHNIQUES OF VISUALIZATION

Generally, there are three regular methods in illustration which shall be studied in this chapter. These are: the digital-digital, mixed media, and freehand-digital techniques *(Figure 3-1, 3-2 and 3-3)*.

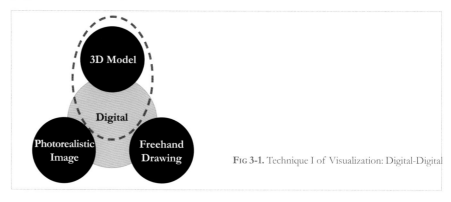

FIG 3-1. Technique I of Visualization: Digital-Digital

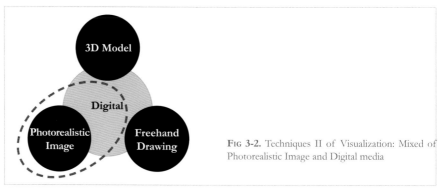

FIG 3-2. Techniques II of Visualization: Mixed of Photorealistic Image and Digital media

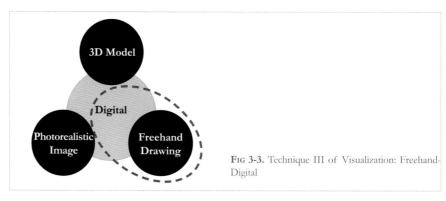

FIG 3-3. Technique III of Visualization: Freehand-Digital

TECHNIQUE I: DIGITAL-DIGITAL

The *Digital-Digital* technique of visualization basically begins with a raw, digital base and is then developed using digital tools. The raw, digital base can be created using different 3D design softwares, such as SketchUp, Rhino, 3D Studio Max and the like.

In the first section of this chapter, we study the eight steps of visualization in digital-digital technique. The following example will support this discussion. *Figure 3-4* and *Figure 3-5* demonstrate the first and last steps of this technique.

FIG 3-1. Technique I of Visualization: Digital-Digital

FIG 3-4. Setting the base with digital image, the first step of technique I
Texas A&M University, TX, USA. Digital media, 11 x 17 in. Copyright to SWA Group

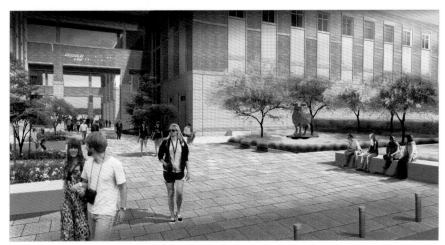

FIG 3-5. Image enhancement with digital media, the final step of technique I
Texas A&M University, TX, USA. Digital media, 11 x 17 in
Illustrated by Shima Rabiee, Copyright to SWA Group

TECHNIQUE II: MIXED MEDIA

In the *Mixed Media* technique, the base is composed of a photorealistic image and 3D model which have been collaged and combined with each other. This technique is also complemented and developed using digital tools. In the second section of this chapter, we discuss the eight steps of visualization in this technique. The following example will support this discussion. *Figure 3-6* shows the first step of this technique—which is a photo of the existing site—and *Figure 3-7* demonstrates the last step of this technique which has been developed using digital elements, tools, and materials.

FIG 3-2. Techniques II of Visualization: Mixed of Photorealistic Image and Digital media

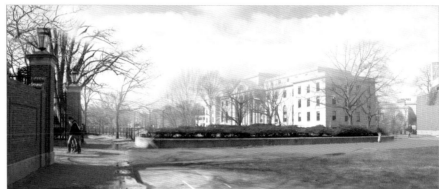

FIG 3-6. Setting the base with site photo, the first step of technique II
The Plaza of Harvard University, MA, USA. Digital media, 11 x 17 in
Photography by Shima Rabiee, Copyright to Stoss Landscape Urbanism

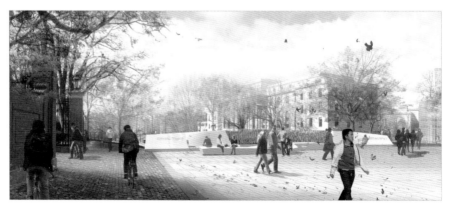

FIG 3-7. Collage of existing site photo and digital media, the final step of technique II
The Plaza of Harvard University, MA, USA. Digital media, 11 x 17 in
Illustrated by Shima Rabiee, Copyright to Stoss Landscape Urbanism

TECHNIQUE III: FREEHAND-DIGITAL

In *Freehand-Digital* technique of visualization, the base is a freehand drawing which is then developed and presented using digital tools. The extent and percentage of freehand and digital work in this technique can vary and they totally depend on the designer's choice. In the final section of this chapter, we discuss the eight steps of visualization in this technique. The following example will support this discussion. *Figure 3-8* shows a freehand drawing sketch which is the first step and base of this technique, and *Figure 3-9* demonstrates the last step of this technique which has been developed using digital elements, tools, and materials.

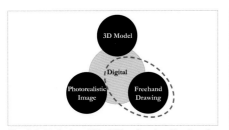

FIG 3-3. Technique III of Visualization: Freehand-Digital

FIG 3-8. Setting the base with freehand sketch, the first step of technique III
Westmoor Park, First Place National Design Competition, CT, USA. Pen on Vellum paper, 11 x 17 in
Illustrated by Shima Rabiee, Copyright to Balsley Balsley Kuhl

FIG 3-9. Collage of freehand drawing and digital media, the final step of technique III.
Westmoor Park, First Place National Design Competition, CT, USA. Pen on Vellum paper, 11 x 17 in
Illustrated by Shima Rabiee, Copyright to Balsley Balsley Kuhl

TECHNIQUE I: DIGITAL-DIGITAL
STEPS AND PROCESS OF VISUALIZATION

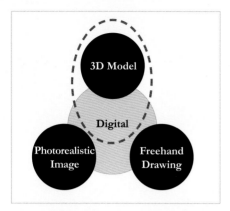

This section focuses on the digital-digital technique. Here, we are going to apply the eight steps of visualization, which we discussed before, on the following example *(Figure 3-10* and *3-11).*

Note that principles such as composition, contrast, harmony, color, visual weight, etc., will not be introduced here in this section, but only their application to visualization will be demonstrated and explained. For a better understanding of these principles and the process of design visualization, please refer to the previous two chapters in which these principles are extensively introduced and studied.

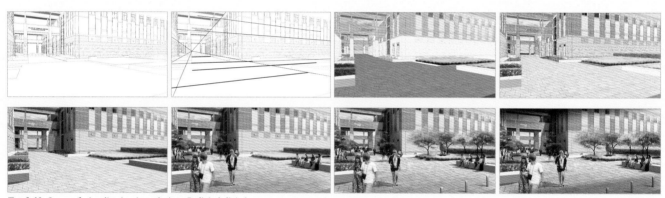

FIG 3-10. Steps of visualization in technique I: digital-digital

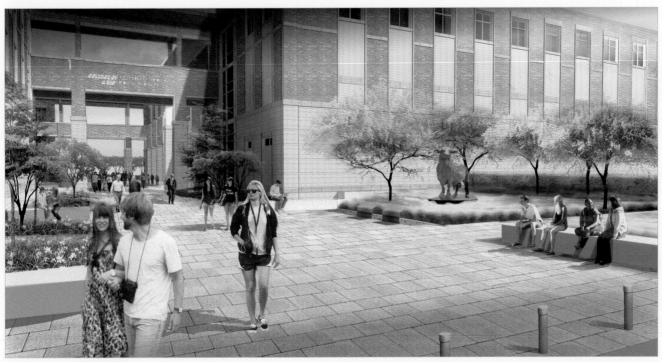

FIG 3-11. Texas A&M University, TX, USA
Digital media, 11 x 17 in
Illustrated by the Shima Rabiee, Copyright to SWA Group

Technique I: Digital-Digital

Step 1: setting the base

The most important and sensitive step in illustration is to begin with a concise, purposeful, and compelling base. The skeleton of the illustration is shaped in this step and the following steps will function as enhancement *(Figure 3-12)*.

In this step, as we export the image as 2D from a 3D model, we consider the following points:

• **Setting the image target:**

At this stage we need to know what we are presenting and how we are presenting it, so that the point of the image is communicated simpler and quicker in the view. The location of the lens in this stage should be determined purposefully based on the target of the image.

• **Generating dynamism and energy in the image:**

Having set the location of the camera in the previous stage, here we change the angle and diaphragm of the camera in order to increase the dynamic and energy of the image. In this stage we try different options until we choose the one that works the best with the target and the design concept.

• **Choosing the image's scale, proportions and dimensions:**

In this stage, we decide with which scale, dimensions and proportions we would like

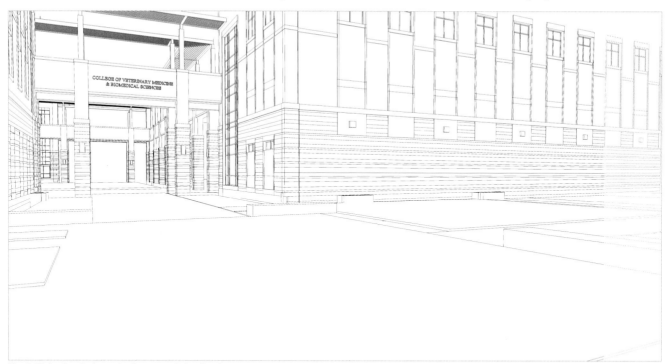

Fig 3-12. Setting the base, the first step of visualization
Texas A&M University, TX, USA. Digital media, 11 x 17 in. Copyright to SWA Group

to present the space. We try different distances to the scene and decide how much of the space context and detail we would like to see in the image, and with what scale, dimensions, and proportions.

***To learn more about this step of visualization, refer to the following discussions:*
- Frame (Chapter two),
- Placement (Chapter two),
- Scale (Chapter two),
- Dynamic and Energy (Chapter two),
- Negative and Positive (Chapter two).

SUMMARY AND TIPS:
- To create interesting visual weight, avoid any symmetry in the image, including the location of horizon line of perspective in the image. The more asymmetric you make the image, the more dynamic you add to it.
- The closer we are to the object and the wider our view/lens is, the more dynamic the image is.
- To make the image more interesting and inviting, avoid straight horizontal and vertical lines. The more diagonal lines and sharp angles that exist in the spatial composition, the more inviting, exciting, and curiosity-evoking the image is.
- Try to work with eye level perspective, as they are more tangible for the viewer as compared to images with bird's-eye views.
- It is important and highly recommended to take into account the negative and positive spaces in this step.
- Observing the proper placement of the target using the principles of golden ratio, the rule of thirds, or the golden point, is recommended while framing the image.
- The choice of dimensions, proportions, and geometry of the frame is also important.

TECHNIQUE I: DIGITAL-DIGITAL

STEP 2: ANALYZING THE FORM AND STRUCTURE OF THE SPACE

The importance of this step lies in that it offers us a better understanding of the spatial structure of the space and the form of objects, their composition, and relationship to the space. This stage helps the development of space in the next stages. It also enables us to control the accuracy of perspective principles, dimensions, and proportions in the image. The following steps, as demonstrated in *Figure 3-13,* should be followed in this stage:

• **Analyzing principles of perspective:**

In this stage we define the angle and position of the camera relative to the scene and find the vanishing points and the horizon line in the image *(Figure 3-13).*

• **Analyzing the spatial structure of space:**

In this stage we recognize the lines and shapes which form the abstract form of the space. Recognizing these lines, which are very influential in the formation of the image structure, helps us remember to amplify them during the development of the image with factors such as color, tone, contrast, etc. and thereby offer the viewer a more clear sense of the space's overall structure, form and composition. This discussion is studied in depth in *Spatial Structure* and *Compositional Gesture* in chapter two.

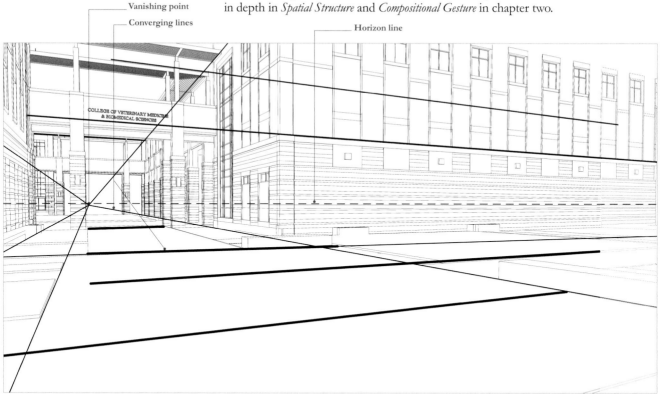

FIG 3-13. Analyzing the form and structure of the space, the second step of visualization
Texas A&M University, TX, USA. Digital media, 11 x 17 in
Illustrated by Shima Rabiee, Copyright to SWA Group

• **Analyzing and drawing the contours of surfaces which compose the space:** In this stage we analyze the internal form of surfaces and shapes in the image and present them as one-directional lines or meshes. These lines, which introduce the inner texture/form of volumes and space, are the same *Contour Lines* which have been elaborated on in chapter one. This helps us develop the image much easier in the next stages. By having the grids or wireframes of the surfaces, the application of materials becomes easier and more accurate, and the placement of elements such as human figures, furniture, etc. is more clear. These lines function as guidelines and give us more control over the accuracy of the proportions of details in perspective views. Also we can control the precision of the perspective at this stage. These lines should not disappear in the final image; and instead they should be reinforced by materials and textures, as the image is developed to help the audience read and understand the three-dimensional form of the space better. This discussion of contour lines is studied in depth in and *Abstract Drawings* and *Internal Form*, chapter one *(Figure 3-14, 3-15 and 3-16)*.

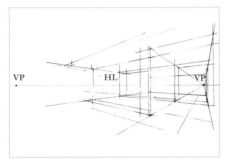

FIG **3-14.** Abstract drawing. Pencil on paper, 8 1/2 x 11 in. Illustrated by Shima Rabiee

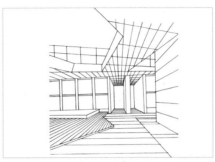

FIG **3-15.** Study of internal form. Pen on paper, 8 1/2 x 11 in. Illustrated by Shima Rabiee

FIG **3-16.** Study of internal form of an urban space. Pen on paper, 11 x 17 in. Illustrated by Shima Rabiee

***To learn more about this step of visualization, refer to the following discussions:*
- Abstract Drawing (Chapter one),
- Internal Form and External form (Chapter one),
- Spatial Structure (Chapter two),
- Negative and Positive (Chapter two).

SUMMARY AND TIPS:
- Drawing and understanding the horizon line and vanishing points in this stage is important, no matter how developed the base is, and what technique we work with, either digital or freehand.
- It is recommended to study and analyze the spatial structure of the space at this stage.
- To develop a better understanding of the overall shape of the individual volumes, their composition, and location in the space, drawing the contour lines is highly recommended. This is an important step, in which we can also control the precision of the perspective and the scale of the details.
- All lines drawn in this stage should comply with the overall perspective principle of the image.

STEP 3: APPLYING COLORS AND MATERIALS

Although this stage can be undertaken with the aid of 3D software in the supplementary stages of 3D modeling, we should take care that the complete and comprehensive introduction of the landscape space demands many details which are sometimes not implementable in 3D software, and instead should be applied to the image in the supplementary stages using a secondary tool/software. The more colors and materials we apply to the space in the 3D model and before exporting the display as a 2D image, the less we will need to process the image afterwards. In fact, the 2D stage is suggested for assigning materials to surfaces which are not introduced while making the 3D model.

The selected example of this section is an image with a raw base and no material applied to its surfaces, which requires the most difficult and time consuming process of visualization. We selected this example on purpose, so that we study the assignment of different materials to it further and in more depth.

The following image, *Figure 3-17*, demonstrates the final look of the third step of visualization, in which all surfaces are defined with materials, colors, and textures.

FIG 3-17. Applying colors and materials, the third step of visualization
Texas A&M University, TX, USA. Digital media, 11 x 17 in
Illustrated by Shima Rabiee, Copyright to SWA Group

In visualization we generally divide materials applied onto the surfaces under four categories (*Figure 3-18*):

A. Materials with plain and textureless surfaces, such as plastic surfaces.

B. Materials with fine and even textures, such as asphalt or concrete.

C. Materials with three-dimensional patterns or grids, such as brick walls or painted walls.

D. Materials composed of a collection of uniform, three-dimensional elements which have been grouped together, such as a field covered by groundcover.

A. Materials and colors **B.** Materials and textures **C.** Materials and tiles **D.** Materials and components

FIG 3-18. Categories of materials in visualization. Digital media, 2 x 3 in

Now we shall briefly introduce each of these materials and visually introduce methods of their application.

A. Applying materials with plain and textureless surfaces *(Figure 3-19)*:

This stage includes the complement of surfaces, such as plastic surfaces, which have plain materials with no texture. This method is also sometimes used for surfaces with texture when the image is presented in a small scale and the texture becomes indistinguishable.

This step can be simply implemented with the aid of the commands Paint Bucket Tool in Adobe Photoshop.

A. Materials and colors

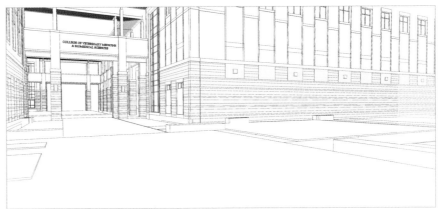

FIG 3-19. Applying materials with plain and textureless surfaces
Texas A&M University, TX, USA. Digital media, 11 x 17 in
Illustrated by Shima Rabiee, Copyright to SWA Group

B. Applying materials with fine and even textures *(Figure 3-20)*:

Surfaces like concrete, asphalt, etc. which have fine and even textures are categorized here. Due to the fineness and evenness of the texture, its direction is not important. But its scale is of great significance and it should be applied carefully and close to reality.

In Adobe Photoshop we can implement this stage by generating a pattern using Pattern Stamp Tool.

B. Materials and textures

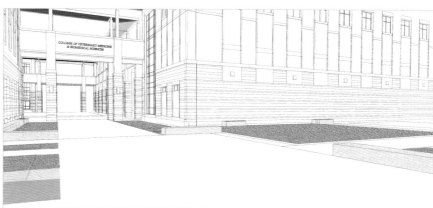

FIG 3-20. Applying materials with fine and even textures
Texas A&M University, TX, USA. Digital media, 11 x 17 in
Illustrated by Shima Rabiee, Copyright to SWA Group

C. Applying materials with two-dimensional patterns or grids/tiles *(Figure 3-21)*:

This stage includes the completion of surfaces with a specific pattern or geometry, such as a brick wall or a painted wall, where both the direction and the scale of components become significantly important. Application of these materials should be carried out with regard to principles of perspective.

Implementing this stage in Adobe Photoshop is simple via free transform tool.

C. Materials and tiles

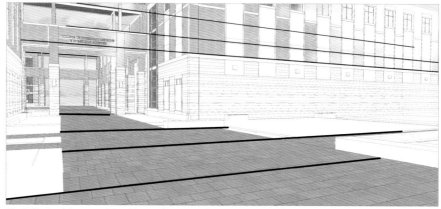

FIG 3-21. Applying materials with two-dimensional patterns or grids/tiles
Texas A&M University, TX, USA. Digital media, 11 x 17 in
Illustrated by Shima Rabiee, Copyright to SWA Group

D. Applying materials composed of a group of uniform, three-dimensional elements *(Figure 3-22)*:

This stage includes covering of surfaces that are composed of a collection of uniform, three-dimensional elements which have been grouped; for example a field which is covered by groundcover. At this stage, we try to arrange the elements not randomly, but orderly and on a presumed mesh. We should take care that the presumed mesh, as well as the three-dimensions and proportions, following principles of perspective.

In implementing this stage in Adobe Photoshop it is recommended to arrange the 3D elements one by one on an assumed grid while respecting the perspective rule of the overall image.

D. Materials and components

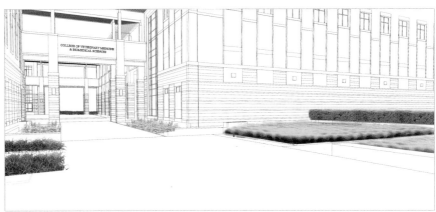

FIG 3-22. Applying materials composed of a group of uniform, three-dimensional elements
Texas A&M University, TX, USA. Digital media, 11 x 17 in
Illustrated by Shima Rabiee, Copyright to SWA Group

***To learn more about this step of visualization, refer to the following discussions:*
- Internal Form (Chapter one),
- Color (Chapter two).

SUMMARY AND TIPS:

- In order to simplify the process of applying materials, we have divided materials into four groups: materials with plain color, those with texture, those with 2D grids or patterns, and those with independent 3D components.
- Pay attention that the textures of materials and the proportions of tiles and patterns should all be presented in exact, real scales.
- The tiles and patterns of materials should be presented based on precise perspective principles and they should follow the horizon line and vanishing points of the image.
- In grouping the 3D components such as groundcovers, it is advised to arrange the 3D elements one by one on an assumed grid, and avoid their random and disorderly dissemination in space.
- In arranging the components of materials, we should take care that their proportions and scales comply with the overall perspective principle of the image.
- We should not worry about homogenizing and balancing colors in this stage.
- In this stage we fill in all the surfaces. No surface in the final image should be left white and without a defined material or color.

STEP 4: CREATING HARMONY AND SENSE OF UNITY

This stage is crucial in visualization, because it enables the viewer to better understand the overall space and facilitates the communication of the design intent, by reducing unnecessary gaze and details and creating cohesion and coherence in the visual weight of the entire image (*Figure 3-23*).

In order to achieve balance, homogeneity, and unity in the harmony of image, we should do the following:

- **Creating balance and unity in the image's visual weight and extent of details:**

We homogenize the extent of elements, details and texture in all points of the image, so that the visual weight of the image is equal everywhere.

- **Reducing gaze and variety in the colors' dimension and temperature:**

At this stage, we review the colors' hue, value, and intensity and modify them, in order to enhance the unity of the image and reduce unnecessary gaze and distraction. We

Lowering the intensity – light yellow to dark yellow
Editing the hue – blue-green to yellow-green
Lowering the contrast – dark green to medium green
Editing the color temperature – cool gray to warm gray

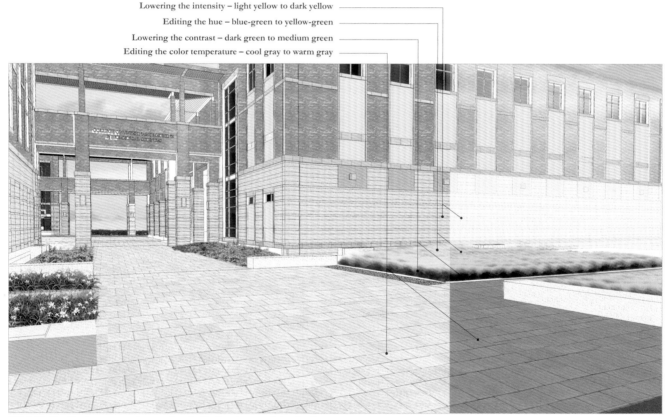

FIG 3-23. Creating harmony and sense of unity, the fourth step of visualization
Texas A&M University, TX, USA. Digital media, 11 x 17 in
Illustrated by Shima Rabiee, Copyright to SWA Group

consider the space's overall lightness and darkness, warmness and coolness, and bring the colors' value and temperature as close as we can to the space's overall harmony; We also reduce the colors' diversity and intensity in the image to prevent gaze and to enable the viewer to understand the image as one space. In this process we should keep in mind the following notes, that were mentioned in the *Harmony* section in chapter two in more depth:

- The colors are affected by their environment.
- The colors are also affected by their surrounding color.
- The color temperature can contribute to create the illusion of depth:

As we explained in the *Color* section in chapter two, warm colors tends to move forward in the space and cool colors tend to recede. And therefore, we may increase and exaggerate the difference of color temperature, to create more depth. For example, to adjust harmony of *Figure 3-23*, the floor is gray concrete. For increasing the illusion of depth, we transformed the cool gray in the foreground to warmer gray, and the warm yellow of the building to cooler yellow. Some adjustment are labeled and described in *Figure 3-23* as examples of the editing process.

***To learn more about this step of visualization, refer to the following discussions:*
- Color (Chapter two),
- Harmony (Chapter two).

SUMMARY AND TIPS:
- First make sure that the image does not contain distracting details. If the space includes furniture, people or other similar elements, eliminate them temporarily, and view the image as simple and pure as you can, so that your eyes can better distinguish color composition and the homogeneity of the overall space.
- Begin with larger elements which occupy greater proportions of the image and which are more impactful. For example, in *Figure 3-23*, start with the ground or with the large building. It is generally a good idea to begin from the ground, which serves as the image's bedding and foundational layer.
- This stage includes adjusting the extent of detail, as well as the colors' dimension and temperature.
- In modifying the color harmony, it is usually suggested that you start from one point and gradually expand your modification; and not that you modify all parts of the image simultaneously.
- With the modification of colors and their values, the space seems more homogeneous and real. It is worth noting that we have not ignored the diversity of the plants' colors and textures, etc., but we shall take care of them in later stages. In the present stage we merely decide the color background which should look homogeneous and harmonic and offer a unified sense of the space's entity.
- *This stage can simply be done in Adobe Photoshop, via Image Adjustments tools such as Hue/Saturation and Levels to homogenize the colors.*

STEP 5: REVEALING THE THREE-DIMENSIONAL FORM
THROUGH IMPLICATION OF LIGHT AND SHADOW

Applying lights and shadows is a very significant and effective stage in visualization. This is the most important stage after setting the base, because communicating the design form and composition as well as its atmosphere are undertaken in this stage *Figure (3-24)*.

Despite the widely-held false belief, this stage is not merely confined to defining a light source and applying the shadows, but it is of higher importance and value. Here are some reasons for its significance:

- **Light and shadow reveal the three-dimensional form of objects and their composition:**

In fact, this is the stage where we can best communicate the three-dimensional form of objects, their position in space, and their composition. As in painting, where light and shadows contribute to the understanding of the form and composition of objects, in visualization too, the concept is better expressed and revealed with the aid of lights and shadows.

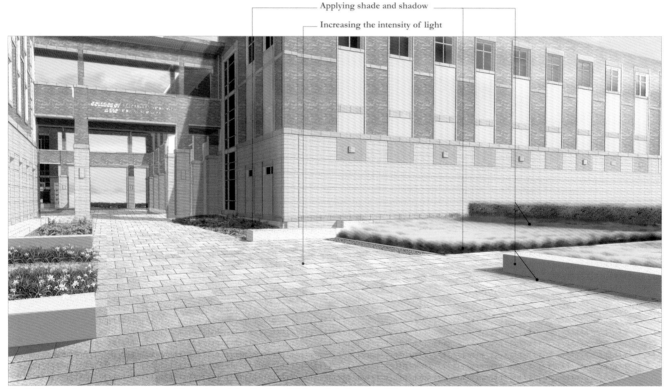

Applying shade and shadow
Increasing the intensity of light

FIG 3-24. Revealing the three-dimensional form through implication of light and shadow, the fifth step of visualization
Texas A&M University, TX, USA. Digital media, 11 x 17 in
Illustrated by Shima Rabiee, Copyright to SWA Group

- **Light and shadow render the space in more real and tangible way and demonstrate the light impact on formation of deign concept:**

This stage renders the space more real, tangible, lively and simply more beautiful. It is in this stage that the intensity of light in the space, the formation of shadows, and the impact of light on the atmosphere and formation of design are demonstrated. Sometimes the direction and quality of light and how it forms shadows is a part of, if not the reason behind, the formation of the design intent, which can be effectively introduced and presented at this stage.

- **Light and shadow have a considerable influence on the composition, movement, focal point and focus of the image which altogether guide the viewer's gaze:**

The choice of daytime in visualization is also crucial, because the angle of sunlight differs as per the time of day, which in turn affects the intensity of light and the forms of shadows. We know that the intensity and form of an image's lightness and darkness influence its visual weight, balance, focal point, and composition, and that how they lead to the guidance or distraction of the gaze. Thus it is recommended that, in order to make the rendering more effective, sunlight direction in different hours of the day should be studied.

- **Light and shadow can also affect the mood, character and sense of the space:**

To study this point, refer to *Contrast* in chapter two.

***To learn more about this step of visualization, refer to the following discussions:*
- Tone (Chapter one),
- Contrast (Chapter two),
- Focal point (Chapter two),
- Visual weight and movement (Chapter two).

SUMMARY AND TIPS:

- Light and shadow reveal the three-dimensional form of objects/space more clearly, present the mood and the atmosphere of the space more vividly, and considerably influence the image's composition. They are also an affective tool for communicating form and composition of design concept, and hence they make up an important topic in design visualization.

- Light and shadow are important components of image composition, because they determine the extent and quality of lightness and darkness on the page, which in turn has a direct impact on the value, focal point and visual weight of the image.

- The choice of day time is very significant in visualization. Sunset hours are rarely opted for; because during them there is much shadow and little light and therefore, little contrast. Noontime is also not a suitable time for rendering because it offers the shortest shadows and highest contrast due to the angle of the sun.

- Note that the color of shadow is not neutral or warm gray, but rather a cool gray or gray with a shade of blue or purple. Cool light has warm shadow and warm light creates cool shadow. The Sun's light, especially the direct light of early morning or late afternoon, which is considered a natural light, is warm, and therefore it creates cool shadows in outdoor rendering.

- By light source we mean the sunlight, that is located above the horizon and shines equally from an infinite distance on all objects.

- In order to emphasize the focal point and to create more contrast in the image, besides making the shadows and shaded surfaces darker we can also render the lit surfaces lighter. Hence, by increasing the intensity of light in the image, we create more contrast and dynamic in the space. As you can see in *Figure 3-27*, the part of the ground which is closer to the focal point seems more bright and interesting.

- The images below, *Figure 3-25, 3-26* and *3-27,* are illustrations of the steps taken in the fifth stage of visualization. The steps are:
- **Taking the final image of the previous step, as a base** *(Figure 3-25).*

FIG 3-25. The base taken from previous step, fourth step of visualization
Texas A&M University, TX, USA. Digital media, 11 x 17 in
Illustrated by Shima Rabiee, Copyright to SWA Group

- **Implementing the light and shadow in the image:**

The light and shadow can be either exported as a 2D image from a 3D model or added manually with respect to light source and principles of perspective *(Figure 3-26)*.

FIG **3-26.** Applying the light and shadow in the image
Texas A&M University, TX, USA. Digital media, 11 x 17 in
Illustrated by Shima Rabiee, Copyright to SWA Group

- **Increasing the intensity of light in the space, and creating more contrast, dynamic, and sense of depth and movement in the image** *(Figure 3-27)*.

FIG **3-27.** Increasing the intensity of light, and creating sense of depth through tone variation
Texas A&M University, TX, USA. Digital media, 11 x 17 in
Illustrated by Shima Rabiee, Copyright to SWA Group

STEP 6: EXPRESSING DEPTH AND SPATIAL QUALITY

This stage involves increasing a sense of three-dimensional illusion and depth in space with the aid of existing elements. This means that we choose some static or dynamic elements in space such as human figures, plants, furniture, etc. and arrange them in a way that the space's three-dimensional properties are intensified and better comprehended *Figure (3-28)*. Note that in this stage, it is not necessary to present all of the elements which we would like to include in the final image; rather we choose those among them which are more effective in creating a sense of scale and depth in the image.

In this stage, there are two steps that should be taken into consideration for increasing depth:

• **Choosing and repeating similar elements in different scales:**

As already mentioned in chapter two, repetition and conjunction of similar elements in the image attracts and mobilizes the gaze, and the higher the number of these elements is, the more the gaze is attracted to the image and moves up on it. For example choosing only one kind of tree is more effective than choosing trees of different kinds. Now if these elements appear in the image repetitively and with different scales, they inevitably imply the depth and three-dimensionality of space and they direct the gaze into the image.

FIG 3-28. Expressing depth and spatial quality, the sixth step of visualization
Texas A&M University, TX, USA. Digital media, 11 x 17 in
Illustrated by Shima Rabiee, Copyright to SWA Group

This changing of the elements' scale creates an effective illusion of depth. It considerably avoids the lingering of the eye on one plan in the image and decreases the image's flatness to a considerable extent (*Figure 3-29* and *3-30*).

This discussion is studied in depth in *illusion of depth* in chapter two *(Figure 3-31)*.

FIG 3-31. Illusion of depth (Cropped image)
Stadium Park Redevelopment, Texas, USA
Digital media, 11 x 17 in
Illustrated by Shima Rabiee, Copyright to SWA Group

FIG 3-29. Increasing sense of depth by repeating human figures in different scales
Texas A&M University, TX, USA. Digital media, 11 x 17 in
Illustrated by Shima Rabiee, Copyright to SWA Group

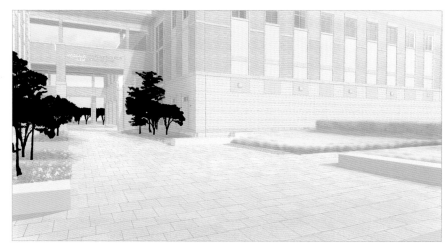

FIG 3-30. Increasing sense of depth by repeating similar trees in different scales
Texas A&M University, TX, USA. Digital media, 11 x 17 in
Illustrated by Shima Rabiee, Copyright to SWA Group

- **Gradually changing the value of similar elements on the page:**

Various value scales can create illusion of depth in the image *(Figure 3-31).* The higher the contrast between the values of similar elements in the image is, the better we develop a sense of their distance and comprehend the depth of the image.

Note that, as discussed in chapter two and demonstrated in *Figure 3-32*, this difference in values of elements should be applied with much care and in the order from foreground

FIG 3-31. Six persimmons
Ink on paper, 14 1/2 x 11 1/4 in
MU-CH'I (13th Century; Chinese)
Ryoko-in, Daitokuji, Kyoto

FIG 3-32. Figures and animals in deep architectural setting (18th-19th century)
Brown ink, pencil and gray wash, 21 1/8 x 29 1/2 in. Gaetano Gandolfi
Los Angeles County Museum of Art, Los Angeles County Fund (54.12.15)
Photo © Museum Associates/ LACMA

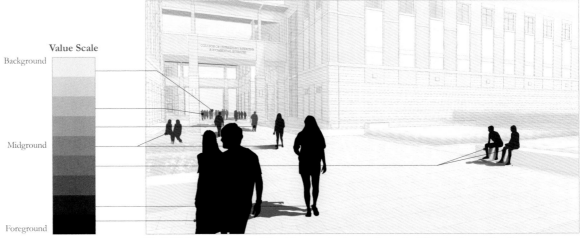

FIG 3-33. Increasing sense of depth by repeating human figures in different values and scales
Texas A&M University, TX, USA. Digital media, 11 x 17 in
Illustrated by Shima Rabiee, Copyright to SWA Group

to background or the other way around, in order to introduce a valid sense of depth to the viewer; to learn more about how to apply the value changes effectively refer to the *Tone* discussion in chapter one. In *Figure 3-33*, as we proceed into the depth of the image the human figures appear lighter with less detail and clarity. Similar to the rule of darkness and lightness which was explained above, the clarity and details of elements decrease as we move towards the depth of the image, and their forms become more general and abstract. Figures in the background are only perceived as general shapes, whereas those in the foreground are sharper and have higher contrast and more details.

***To learn more about this step of visualization, refer to the following discussions:*
- Illusion of depth (Chapter two),
- Grouping and Directions (Chapter two),
- Tone (Chapter one).

SUMMARY AND TIPS:
- Adding elements to the space is not only to render it more vivid and dynamic, but also to complement and intensify the sense of space's three-dimensional structure.
- In organizing and arranging elements, we place them on three different planes—foreground, mid-ground and background—to grant the viewer a stronger sense of depth.
- It is recommended to arrange the elements evenly in the width of the image, so that the viewer's eyes move across the page to explore the entire image/space.
- It is highly recommended to arrange the elements in groups. This arrangement also influences the composition, movement and visual weight of the image. The more homogeneous and clustered elements are presented in the image, the more they will contribute to the composition and sense of depth.
- Design visualization aims at presenting the atmosphere of the designed space, as well as its form and composition. Therefore when using human figures, plants, and etc. to create dynamic in the space, it is recommended to apply elements that are relevant to the complex and further engaged with the program of the design, so that we bring the image closer to reality and we better communicate the design objective.
- If you are adding furniture, cars, plants or any other elements to the rendering, make sure that their make, type or style are compatible with the atmosphere and intent of the designed space.
- The contrast of value and intensity in foreground and background directly contributes to the sense of depth in space.

Step 7: enhancing the compositional structure

This stage is dedicated to complementing the image by adding the design elements that complement the space while enhancing the composition and focal point *(Figure 3-34)*. Note that the necessity of separating this stage from the previous one lies in gaining more control over the image's composition and visual elements. For example, if we would like to insert a number of elements into the image, it is better to insert only 1/3 of them first, at stage sixth. Then, after we studied how to organize them to support and enhance the composition, visual weight, desired depth and eye movement in the image, we get into more detail and insert the remaining elements with the same logic as in stage seventh. If we insert all elements simultaneously, reaching the ideal composition would become very difficult. This is like *seeing from the big picture to the detail* in art, which means that the drawing is made in multiple stages and each stage should appear complete in it's own way. The further stages are simply applied to make it richer, more real and beautiful.

Although no specific rules apply to this stage, it should be undertaken with much care, because adding elements randomly can affect the visual weight, balance, and harmony of the image significantly as well as the atmosphere and character of the space. It can also influence the design clarity and the image's composition.

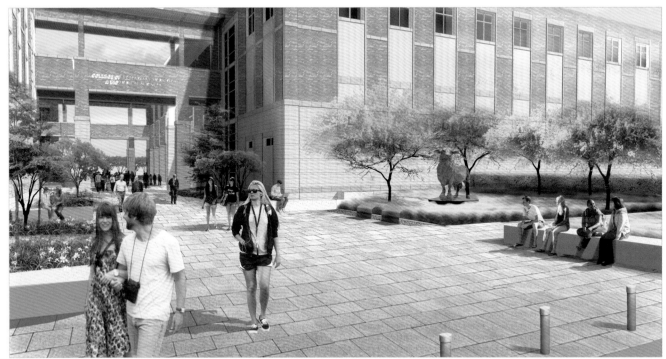

Fig 3-34. Enhancing the compositional structure, the seventh step of visualization
Texas A&M University, TX, USA. Digital media, 11 x 17 in
Illustrated by Shima Rabiee, Copyright to SWA Group

***To learn more about this step of visualization, refer to the following discussions:*
- *Illusion of depth (Chapter two),*
- *Visual weight and movement (Chapter two),*
- *Tone (Chapter one),*
- *Harmony (Chapter two),*
- *Focal point (Chapter two).*

SUMMARY AND TIPS:

- As mentioned in the previous section, it is highly recommended to employ less individual and more grouped elements.
- The aesthetic value of the elements you choose and the extent of their details has a direct influence on the quality of the final rendering. Therefore paying enough attention to the choice of elements is highly recommended.
- Like in the previous stage, try to choose human figures which are compatible with your design program to introduce it better and make it more tangible and believable for the viewer.
- In adding the figures, make sure that the type of space users and their age, style, and formality or casualness comply with the space's character, atmosphere and program.
- The human figures' activity and their dynamism directly influences the energy and atmosphere of your image, so they should be added with much sensibility.
- In the process of adding the elements, constantly check their hue, value, and intensity and make them compatible and homogeneous with their surrounding colors, so that their presence in the space becomes more tangible and does not cause gazing and distraction.
- Avoid filling all angles and points of the space with objects, which in turn results in a monotonous image in which the value of visual weight and positive and negative spaces are lost.
- Place the elements in a way that they complement and amplify the image's composition, visual weight, and focal point, and not disarrange them.
- In *Figure 3-35* and *3-36,* you can compare the two steps, step sixth and seventh and see the additional objects added at this stage to complement and enhance the composition.

FIG 3-35. Step 6: Expressing depth and spatial quality
Texas A&M University, TX, USA. Digital media, 11 x 17 in
Illustrated by Shima Rabiee, Copyright to SWA Group

FIG 3-36. Step 7: Enhancing the compositional structure
Texas A&M University, TX, USA. Digital media, 11 x 17 in
Illustrated by Shima Rabiee, Copyright to SWA Group

STEP 8: CREATING DYNAMICS, MOVEMENT, AND ENERGY

This is the stage in which we vivify the space in order to better communicate its atmosphere, meaning that we offer the viewer a stronger sense of the movement and energy present in the illustrated space. We also apply the last touches on the image for the sake of composition and representation (*Figure 3-37*).

In this stage, we review the three following steps:

- **Demonstrating movement:**

Movements in space grant an animated quality to the image and offer the viewer a stronger sense of energy and mobility in space. Factors such as the blowing of the wind, the flow of water, the movement of cars and people etc. are attended to in this stage.

- **Demonstrating materials through light effects and reflections:**

In this step we study local lightings and reflections on the surfaces of materials, which leads to a better comprehension of the material and spatial qualities of the space. The surfaces' opacity, the materials quality, the space's modernity or oldness, etc. become more clear and tangible with the aid of this step.

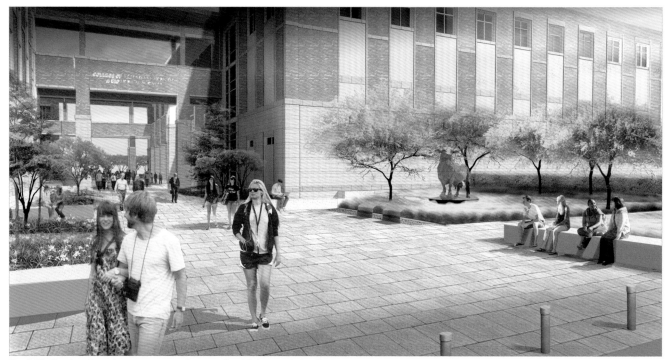

FIG 3-37. Creating dynamics, movement, and energy, the eighth step of visualization
Texas A&M University, TX, USA. Digital media, 11 x 17 in
Illustrated by Shima Rabiee, Copyright to SWA Group

- **Applying filters and effects for the sake of presentation:**
These are filters such as sharpness, saturation and lightness/darkness which only influence the image's composition and presentation, and not its spatial quality. For example, in *Figure 3-37* a dark filter on the margins causes the eye to focus on the center. It also amplifies the image's diagonal compositional gesture.

***To learn more about this step of visualization, refer to the following discussions:*
- Tone (Chapter one),
- Visual weight and movement (Chapter two).

SUMMARY AND TIPS:
- This stage involves vivifying the image and creating dynamism in the space.
- The most crucial undertaking in making a static image dynamic is to demonstrate movement in the space.
- Reflections are also amplified in this stage.
- Finally, filters which grant the image more visual interest and strengthen its composition are added.
- Note that not all of these techniques are necessarily applicable to all images.

TECHNIQUE II: MIXED MEDIA (PHOTOREALISTIC IMAGE + DIGITAL MEDIA)
STEPS AND PROCESS OF VISUALIZATION

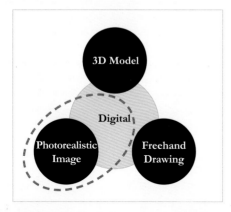

This section focuses briefly on the mixed media technique. In the process of applying this technique, we follow the same eight stages of visualization which were introduced at the beginning of this chapter and in the previous example, with a slight difference in the process of applying those stages.

Note that a deeper and more comprehensive discussion of the eight steps of visualization was undertaken in example one of this chapter and here, in the current example, *Figure 3-38* and *3-39,* these steps are studied only briefly, so that their application in mixed media technique also becomes clear.

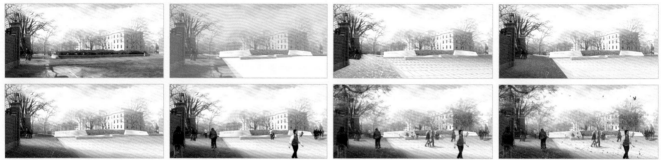

FIG 3-38. Steps of visualization in technique II, mixed media

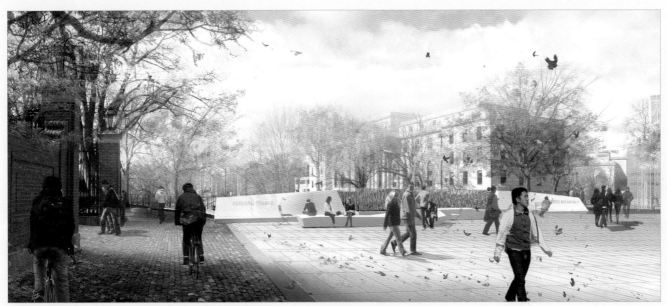

FIG 3-39. The Plaza at Harvard University, MA, USA (Constructed and award-winning project)
Digital media, 11 x 17 in
Illustrated by Shima Rabiee, Copyright to Stoss Landscape Urbanism

Step 1: Setting the Base

This stage includes the following steps:

1. Photographing the existing site and editing the site photo *(Figure 3-41)*:
In this step, we take a few shots from the existing site and select the one that communicates the design intent better. Then, we edit the photo and eliminate unnecessary details from the site, in order to avoid the distractions and create a clear and homogeneous image as a base for rendering.

2. Exporting a two-dimensional image from a three-dimensional model so that the image's angle complies with that of the photo taken of the site *(Figure 3-42)*:
In order for the two images, the existing site photo and the exported image from a the 3D model, to comply in perspective so that they can be superimposed, their vanishing points, horizon lines, diaphragm, view angles, and scales should be identical.

3. Superimposing the real and the digital image *(Figure 3-43)*:
In this stage we superimpose the two images, the existing site photo and the exported image from a 3D model *(Figure 3-43)*. This is the best way of design communication, as it demonstrates the design on the existing site and helps comprehend the final impression of space with the design components.

- Note that it is not necessary in this stage to have a complete built three-dimensional model of the entire site. Sometimes we use the collage technique, meaning that we build and arrange the individual designed objects on the site's image. In any case (whether collage or export of the image from a three-dimensional model), the perspective angle of these images should comply with that of the site photograph.

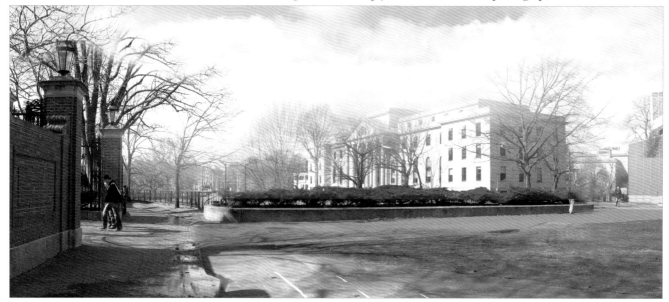

FIG 3-40. Setting the base, the first step of visualization (Existing site image)
The Plaza of Harvard University, MA, USA. Digital media, 11 x 17 in
Photographed by Shima Rabiee, Copyright to Stoss Landscape Urbanism

***To learn more about this step of visualization, refer to the following discussions:*
- Frame, placement, scale, dynamic and energy, and negative and positive (Chapter 2),
- Technique I: Digital-Digital, Step 1: Setting the base (Chapter 3).

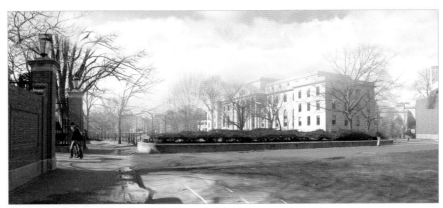

FIG 3-41. Taking photo from the existing site and editing it

FIG 3-42. Exporting a two-dimensional image from a three-dimensional model so that the image's angle complies with that of the photo taken of the site

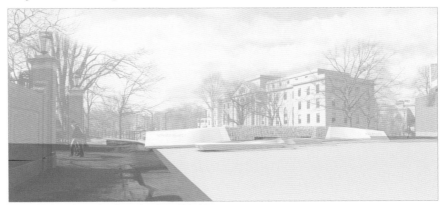

FIG 3-43. Superimposing the real and the digital image

STEP 2: ANALYZING THE FORM AND STRUCTURE OF THE SPACE

Now that we have an image that is a collage of the existing site photo and the two-dimensional image of the 3D model with design component, as demonstrated in *Figure 3-44*, we take the following steps in this stage:

• **Analyzing principles of perspective:**

We draw the horizon line, vanishing points, and the converging lines for the overall space.

• **Analyzing the abstract structure of the space:**

We study the fundamental lines which introduce the abstract of the space.

• **Analyzing the inner form or contour lines of surfaces which compose the objects and the space:**

In this stage we analyze the internal form of surfaces and shapes in the image and present them as one-directional lines or meshes. These lines, which introduce the texture or contour of the surfaces help us develop the image easier in the next steps. They function as guidelines and give us more control over the accuracy of the proportions of details in perspective views. All lines drawn in this step should comply with the overall perspective principle of the image.

***To learn more about this step of visualization, refer to the following discussions:*

- Abstract drawing, Internal form, and External form (Chapter 1),

- Spatial structure, Negative and positive (Chapter 2),

- Technique I: Digital-Digital, Step 2: Analyzing the form and structure of the space (Chapter 3).

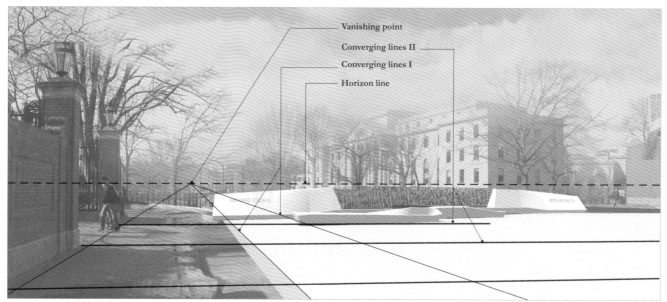

FIG 3-44. Analyzing the form and structure of the space, the second step of visualization
The Plaza of Harvard University, MA, USA. Digital media, 11 x 17 in
Illustrated by Shima Rabiee, Copyright to Stoss Landscape Urbanism

Step 3: Applying Colors and Materials

As mentioned in the previous example, in technique I of this chapter, in order to simplify the process of applying materials, we have divided materials into four groups:

A. Materials with plain and textureless surfaces.

B. Materials with fine and even textures.

C. Materials with two-dimensional patterns or grids.

D. Materials composed of a collection of uniform, three-dimensional elements.

In this example, *Figure 3-45,* we incorporate the second and third categories, B and C, as described below:

B. Materials with fine and even textures:

We apply the concrete color in this step while respecting the real scale of its texture in the image.

C. Materials with patterns or grids:

In this example, we project the bricks and concrete pavers with their exact scale and dimensions on the floor.

The proportion and the scale of the tiles and pavers are significantly important in this step. Also Application of these materials should be carried out with regard to principles of perspective and should follow the overall horizon line and vanishing points of the image.

***To learn more about this step of visualization, refer to the following discussions:*

- Internal Form (Chapter 1),

- Color (Chapter 2),

- Technique I: Digital-Digital, Step 3: Applying color and material (Chapter 3).

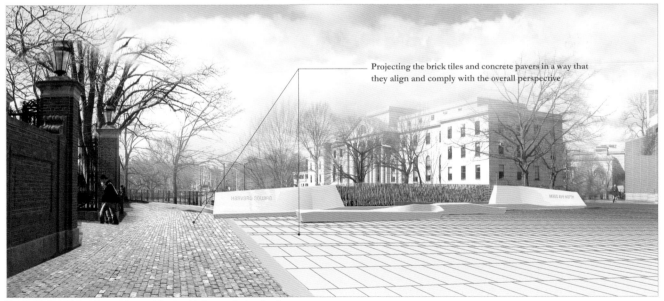

Projecting the brick tiles and concrete pavers in a way that they align and comply with the overall perspective

Fig 3-45. Applying colors and materials, the third step of visualization
The Plaza of Harvard University, MA, USA. Digital media, 11 x 17 in
Illustrated by Shima Rabiee, Copyright to Stoss Landscape Urbanism

STEP 4: CREATING HARMONY AND SENSE OF UNITY

This stage includes adjusting the visual weight and color harmony of the image. In order to achieve balance, homogeneity and unity in the harmony of image, we should do the following:

- **Creating balance and unity in the image's visual weight and extent of details:**

We homogenize the extent of the details used in the entire image to achieve an image with equal/balanced visual weight in all points.

- **Reducing gaze and variety in the colors' dimension and temperature:**

- As mentioned in chapter two, the colors affect their surrounding color. Therefore, in order to achieve a balanced and unified image, we revise the object's colors and adjust their hue, value, and intensity accordingly, so that all materials seem integrated, situated in the same space, and lit by the same light source *(Figure 3-46)*.

***To learn more about this step of visualization, refer to the following discussions:*
- Color and Harmony (Chapter 2),
- Technique I: Digital-Digital, Step 4: Creating harmony and sense of unity (Chapter 3).

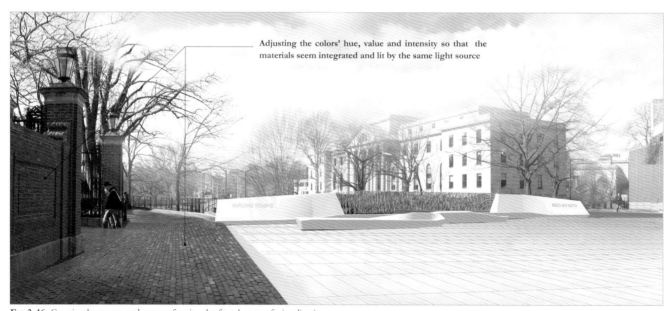

Adjusting the colors' hue, value and intensity so that the materials seem integrated and lit by the same light source

FIG 3-46. Creating harmony and sense of unity, the fourth step of visualization
The Plaza of Harvard University, MA, USA. Digital media, 11 x 17 in
Illustrated by Shima Rabiee, Copyright to Stoss Landscape Urbanism

STEP 5: REVEALING THE THREE-DIMENSIONAL FORM
THROUGH IMPLICATION OF LIGHT AND SHADOW

This stage has a direct impact on the composition as it defines the focal point and visual weight of the image. As we discussed in the previous example, the followings are a few reasons that make this step significant:

- **Light and shadow reveal the three-dimensional form of objects and their composition.**
- **Light and shadow render the space in more real and tangible way and demonstrate the light impact on formation of deign concept.**
- **Light and shadow have a considerable influence on the composition, movement, focal point and focus of the image which altogether guide the viewer's gaze.**
- **Light and shadow can also affect the mood, character, and sense of the space.**

Therefore in visualization we tend to increase the extent of the shadow to express the form better and enhance the composition and movement on the page. Also we increase the contrast of value and intensity of light to determine the focal point better in the image. Note that the color of shade is not neutral gray; It's cool gray or gray with a shade of blue or purple *(Figure 3-47)*.

***To learn more about this step of visualization, refer to the following discussions:*
- Tone (Chapter 1),
- Contrast, Focal point and Visual weight and movement (Chapter 2),
- Technique I: Digital-Digital, Step 5: Revealing the three-dimensional form (Chapter 3).

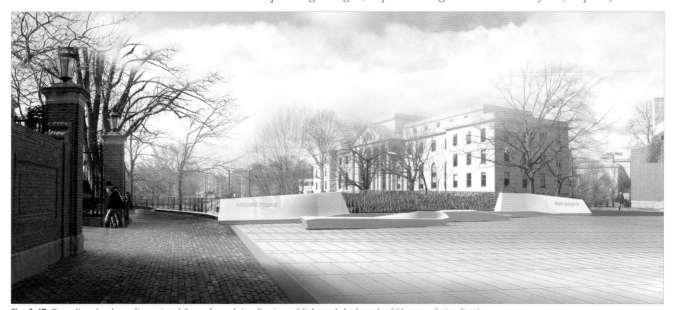

FIG 3-47. Revealing the three-dimensional form through implication of light and shadow, the fifth step of visualization
The Plaza of Harvard University, MA, USA. Digital media, 11 x 17 in
Illustrated by Shima Rabiee, Copyright to Stoss Landscape Urbanism

STEP 6: EXPRESSING DEPTH AND SPATIAL QUALITY

As discussed in the previous example, there are two methods for further expressing the depth:

- **Choosing and repeating similar elements in different scales** *(Figure 3-49 and 3-50).*
- **Gradually changing the value of similar elements on the page** *(Figure 3-51 and 3-52).*

- In organizing and arranging elements, we place them on three different planes—foreground, mid-ground and background—to grant the viewer a stronger sense of depth.

- It is recommended to arrange the elements evenly in the width of the image, so that the viewer's eyes move across the page to explore the entire image/space.

- It is recommended to arrange the elements in groups. This arrangement also influences the composition, movement, and visual weight of the image.

- Design visualization aims at presenting the atmosphere of the designed space, as well as its form and composition. So when using human figures, it is recommended to use figures that are more engaged with the program to better communicate the design objective and the sense of the space.

- The contrast of value and intensity of foreground and background contributes to the sense of depth in space *(Figure 3-48).*

**To learn more about this step of visualization, refer to the following discussions:*
- *Tone (Chapter 1),*
- *Illusion of depth, Grouping and directions (Chapter 2),*
- *Technique I: Digital-Digital, Step 6: Expressing depth and spatial quality (Chapter 3).*

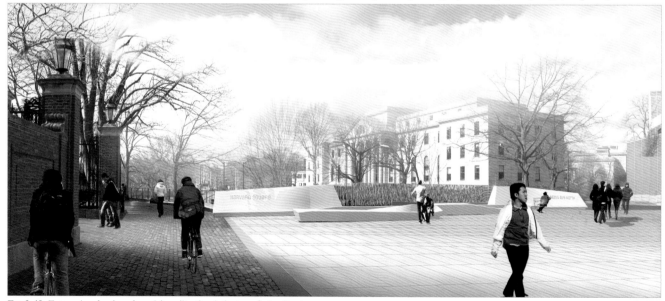

FIG 3-48. Expressing depth and spatial quality, the sixth step of visualization
The Plaza of Harvard University, MA, USA. Digital media, 11 x 17 in
Illustrated by Shima Rabiee, Copyright to Stoss Landscape Urbanism

FIG 3-49. Illusion of depth (Cropped image)
Stadium Park Redevelopment, Texas, USA
Digital media, 11 x 17 in
Illustrated by Shima Rabiee; Copyright to SWA Group

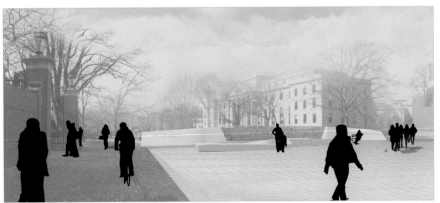

FIG 3-50. Increasing sense of depth by choosing and repeating similar elements in different scales
The Plaza of Harvard University, MA, USA. Digital media, 11 x 17 in
Illustrated by Shima Rabiee, Copyright to Stoss Landscape Urbanism

FIG 3-51. Six persimmons (cropped image)
Ink on paper, 14 1/2 x 11 1/4 in
MU-CH'I (13th Century; Chinese)
Ryoko-in, Daitokuji, Kyoto

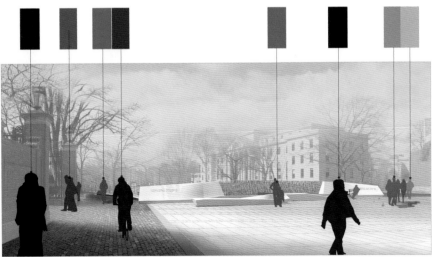

FIG 3-52. Increasing sense of depth by gradually changing the value of similar elements on the page
The Plaza of Harvard University, MA, USA. Digital media, 11 x 17 in
Illustrated by Shima Rabiee, Copyright to Stoss Landscape Urbanism

STEP 7: ENHANCING THE COMPOSITIONAL STRUCTURE

- **Adding the design elements that complement the space while enhancing the composition and focal point** *(Figure 3-53)*:

A few tips to consider in this step:

- Avoid filling the space evenly and leave some negative space.

- Place the elements in a way that they complement and amplify the image's composition and focal point and not disarrange them.

- It is recommended to employ less individual and more grouped elements.

- Like in the previous stage, try to choose human figures which are compatible with your design program to make your design more tangible within the context of the site. The type of users, their age, style and formality or casualness should comply with the space's character, atmosphere and program.

- Also the human figures' activity and their dynamism, directly influences the energy and atmosphere of your image, so they should be added with much sensibility.

- In the process of adding the elements constantly check their hue, value, and intensity and make them compatible and homogeneous with their surrounding colors, so that their presence in the space becomes more tangible and does not cause gazing and distractions.

***To learn more about this step of visualization, refer to the following discussions:*

- Tone (Chapter 1),

- Illusion of depth, Visual weight and movement, Harmony, Focal point (Chapter 2),

- Technique I: Digital-Digital, Step 7: Enhancing the compositional structure (Chapter 3).

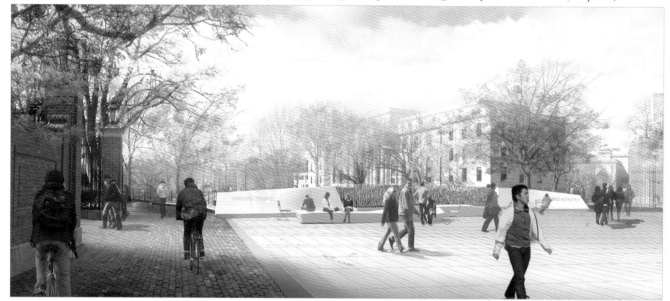

FIG 3-53. Enhancing the compositional structure, the seventh step of visualization
The Plaza of Harvard University, MA, USA. Digital media, 11 x 17 in
Illustrated by Shima Rabiee, Copyright to Stoss Landscape Urbanism

STEP 8: CREATING DYNAMICS, MOVEMENT, AND ENERGY

In this stage we offer the viewer a stronger sense of the movement and energy present in the illustrated space by the three following techniques; 1) Demonstrating movement, 2) Demonstrating reflections, and 3) Applying filters and effects for the sake of presentation. In this image, *Figure 3-54,* we incorporate the first and third techniques as described below:

• **Demonstrating movement:**

- Movements in space grant an animated quality to the image and offer the viewer a stronger sense of energy and mobility in space. Factors such as the blowing of the wind, the flow of water, the movement of cars and people etc. are attended to in this stage. This image beautifully exemplifies this step. The movement of autumn leaves on the ground has created a beautiful image of the space's dynamism and its being windy.

• **Applying filters and effects for the sake of presentation:**

- Finally, filters which grant the image more visual interest and strengthen its composition are added. These are filters such as sharpness, saturation and lightness/darkness which only influence the image's composition and presentation, and not its spatial quality. For example, in this image, a dark filter on the margins causes the eye to focus on the center. It also amplifies the image's diagonal compositional gesture.

- Note that not all of these techniques are necessarily applicable to all images.

***To learn more about this step of visualization, refer to the following discussions:*

- Tone (Chapter 1),

- Visual weight and movement(Chapter 2),

- Technique I: Digital-Digital, Step 8: Creating dynamics, movement, and energy (Chapter 3).

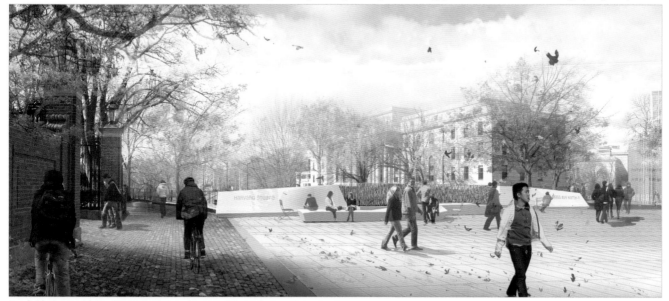

FIG 3-54. Creating dynamics, movement, and energy, the eighth step of visualization
The Plaza of Harvard University, MA, USA. Digital media, 11 x 17 in
Illustrated by Shima Rabiee, Copyright to Stoss Landscape Urbanism

TECHNIQUE III: FREEHAND-DIGITAL
STEPS AND PROCESS OF VISUALIZATION

This section focuses on the freehand-digital technique. Here, we will see that using the eight steps explained at the beginning of this chapter, it is possible to achieve a nice expressive rendering using the freehand technique. Given that the entire process of visualization is the same in any technique, with very little variation, we will explain this example briefly to show how these eight steps of visualization are applied using the freehand-digital technique.

For a deeper and more comprehensive understanding of these steps, refer to example one of this chapter, and to example two for further study.

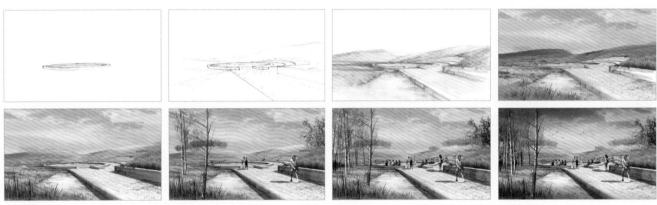

FIG 3-55. Steps of visualization in technique III, freehand-digital

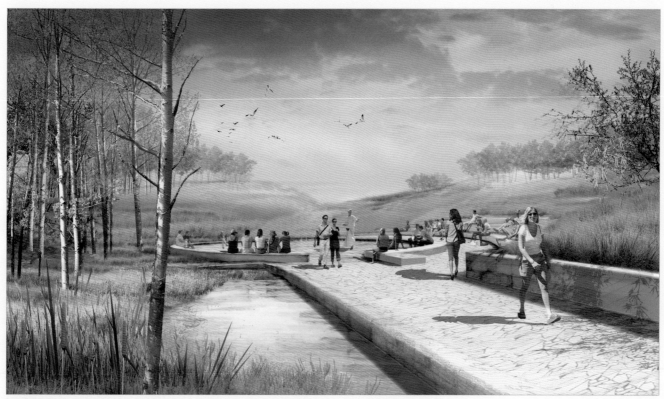

Fig 3-56. Westmoor Park, First Place National Design Competition, CT, USA
Mixed media (freehand-digital), 11 x 17 in
Illustrated by Shima Rabiee, Copyright to Balsley Balsley Kuhl

STEP 1: SETTING THE BASE

At this stage, we follow the below step:

- **Preparing a simple and abstract sketch of the details or the totality of the designed space** *(Figure 3-57)*.

In this example, in which we are combining the drawing with digital media, we start with a drawing of type II, which was introduced in the *Abstract Drawings* discussion. This drawing should be made with great precision and based on the principles of perspective, so that we can gradually develop it, add more details to it and combine it with digital media. As we mentioned in the *Abstract Drawings* discussion, drawing type II are usually produced in the two following ways:

A. Drawing from whole to component:

This means sketching the overall structure of a space of our choice and modifying it based on the design concept, and then adding more details and elements to it. *Figure 3-58* illustrates the process of this kind of drawing.

B. Drawing from component to whole:

This means sketching an element or a component that we would like to include in our design, and then gradually adding the context and surrounding environment to it

FIG 3-57. Setting the base, the first step of visualization
Westmoor Park, First Place National Design Competition, CT, USA. Pen on Vellum paper, 11 x 17 in
Illustrated by Shima Rabiee, Copyright to Balsley Balsley Kuhl

based on our design concept. This development of the drawing should comply with the perspective principles of the element we started with—namely with its angle, horizon line, and vanishing points—so that the resulting context and space becomes homogenous. The following example, *Figure 3-59,* demonstrates this approach.

The example of this discussion, *Westmoor Park,* also follow this approach. The drawing began from a round seat wall which offers a friendly, cozy and interesting space for gatherings, and from that point, the design gradually evolves based on the design concept (*Figure 3-61* and *3-62).*

***To learn more about this step of visualization, refer to the following discussions:*
- Abstract drawings (Chapter 1),
- Frame, placement, scale, dynamic and energy, and negative and positive (Chapter 2),
- Technique I: Digital-Digital, Step 1: Setting the base (Chapter 3).

Step 1: Drawing the overall structure of a space

Step 2: Modifying the space based on the design concept and adding further details to it

FIG 3-58. The process of creating a rendering from *whole to component*. Operation Chamartin, Madrid, Spain
Freehand drawing, 11 x 17 in. Illustrated by Shima Rabiee

Step 1: Drawing a small element/design component

Step 2: Developing the surrounding context based on the design concept

FIG 3-59. The process of creating a rendering from *component to whole*. Design studio project, Darakeh, Tehran
Freehand drawing, 11 x 17 in. Illustrated by Shima Rabiee

STEP 2: ANALYZING THE FORM AND STRUCTURE OF THE SPACE

At this stage as demonstrated in *Figure 3-60*, we follow the below steps:

• **Analyzing principles of perspective** *(Figure 3-61)*:

At this stage, we draw all the elements of perspective such as the vanishing points and the horizon line, and we make sure that all principles of perspective are followed.

The discussion of this stage is studied in depth in *Abstract Drawings* in chapter one *(Figure 3-63)*.

• **Developing the remaining parts of the design in the abstract sketch, based on the principles of perspective considered for the entire space, and drawing the inner forms or contours of surfaces which compose the objects and the space** *(Figure 3-62)*:

We draw the contour lines of the surfaces to demonstrate the details and the proportions of the materials which constitute the space. This also helps create a grid in which we can embed the elements of the space easier in the following stages. Please note all lines drawn in this stage should comply with the overall perspective principle of the image. This discussion of contour lines is studied in depth in *Internal Form*, chapter one through *Figure 3-64,* and *3-65)*.

FIG 3-60. Analyzing the form and structure of the space, the second step of visualization
Westmoor Park, First Place National Design Competition, CT, USA. Pen on Vellum paper, 11 x 17 in
Illustrated by Shima Rabiee, Copyright to Balsley Balsley Kuhl

FIG 3-61. Analyzing principles of perspective. Westmoor Park, First Place National Design Competition, CT, USA. Pen on Vellum paper, 11 x 17 in. Illustrated by Shima Rabiee, Copyright to Balsley Balsley Kuhl

FIG 3-62. Developing the sketch based on the design concept, and drawing the contour lines. Westmoor Park, First Place National Design Competition, CT, USA. Pen on Vellum paper, 11 x 17 in. Illustrated by Shima Rabiee, Copyright to Balsley Balsley Kuhl

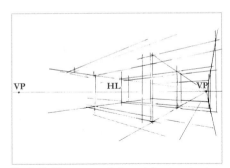

FIG 3-63. The process of abstract drawing, step two. Pencil on paper, 8 1/2 x 11 in. Illustrated by Shima Rabiee

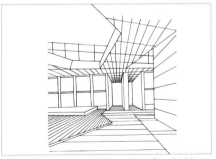

FIG 3-64. Study of internal form, sketch from McMurtry Building at Stanford University. Pen on paper, 8 1/2 x 11 in. Illustrated by Shima Rabiee

FIG 3-65. Study of internal form of an urban space. Pen on paper, 11 x 17 in. Illustrated by Shima Rabiee

***To learn more about this step of visualization, refer to the following discussions:*
- Abstract Drawing, Internal Form, and External form (Chapter one),
- Spatial Structure, Negative, and Positive (Chapter two),
- Technique I: Digital-Digital, Step 2: Analyzing the form and structure of the space (Chapter 3).

STEP 3: APPLYING COLORS AND MATERIALS

At this stage, we go though the process of applying materials—which we already defined under four different categories in previous examples—with freehand and digital techniques through the following steps:

1. Applying materials with freehand *(Figure 3-66)*:

Applying the color to all the planes with the freehand technique and defining each plane's background color. All surfaces, especially those of the softscape, should be colored with free hand, so that a homogenous harmony is created in the entire image. This resembles the underpainting process in painting, in which the entire canvas is colored with a monochromatic/homogeneous harmony and prepared for the following layers. Although this stage is valuable and complete in itself, adding further layers on top of it makes its three-dimensionality and materials richer, more real, and more comprehensible. To better understand this similar concept of creating painting and freehand-digital rendering with two layers, look at the two examples in the following page, the painting of *Raven* in *Figure 3-69* and *3-70,* and the freehand-digital rendering in *Figure 3-67* and *3-68.*

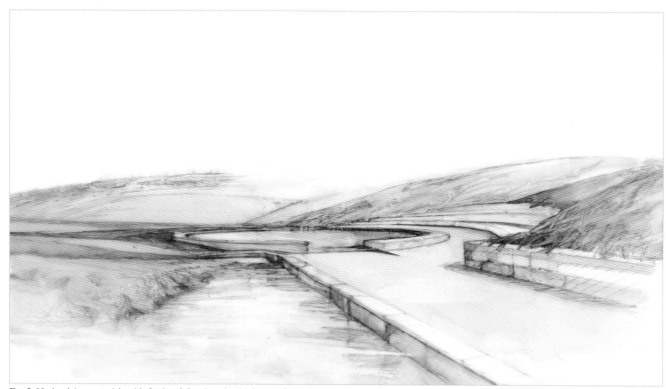

Fɪɢ 3-66. Applying materials with freehand drawing, the third step of visualization
Westmoor Park, First Place National Design Competition, CT, USA. Pen on Vellum paper, 11 x 17 in
Illustrated by Shima Rabiee, Copyright to Balsley Balsley Kuhl

In the freehand-digital technique, the freehand drawing can be done with colored pencil, watercolor, pastel, marker or any other art medium. In this specific example of *Westmoor Park*, in *Figure 3-67*, marker has been used on velum paper. The paper's texture has given the straight, rigid, and dry marker lines a sense of liquidity and has enhanced mixing the colors.

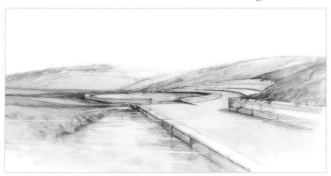

FIG 3-67. Applying materials with freehand drawing
Westmoor Park, First Place National Design Competition, CT, USA
Pen and marker on Vellum paper, 11 x 17 in
Illustrated by Shima Rabiee, Copyright to Balsley Balsley Kuhl

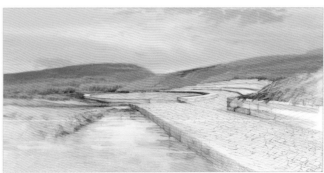

FIG 3-68. Applying materials in digital
Westmoor Park, First Place National Design Competition, CT, USA
Mixed media (collage of freehand drawing and digital media), 11 x 17 in
Illustrated by Shima Rabiee, Copyright to Balsley Balsley Kuhl

FIG 3-69. Raven (Underpainting: The first layer of painting)
Oil on Panel, 16 x 20 in
Painted by Shima Rabiee

FIG 3-70. Raven (The second layer of painting)
Oil on Panel, 16 x 20 in
Painted by Shima Rabiee

2. Applying materials in digital *(Figure 3-71)*:

The next step is to digitally apply the material which covers the surfaces. Given that we have a homogenous image with freehand drawing which functions as background, the extent of the coverage of the digital elements is not constant and it depends on the designer's choice. The more digital elements are used, the richer the image gets and the more realistic the space looks.

In this image, the following digital elements are added to freehand drawing:

A. The cobblestone path that is placed in the foreground of the image. Note that the scale and direction of the stone blocks also follow the principles of perspective.

B. The shrubs that are added to different parts of the landscape. The number and density of these shrubs depend on the designer's choice. In this image, they are placed in the foreground, midground, and background and they cover a significant area of the image. Note that the scale and the coarseness or softness of the textures of these shrubs vary based on the depth and principles of perspective. Shrubs which are further away are viewed vaguer, softer, and more homogenous and they have a milder color, whereas those which are situated closer to the viewer are

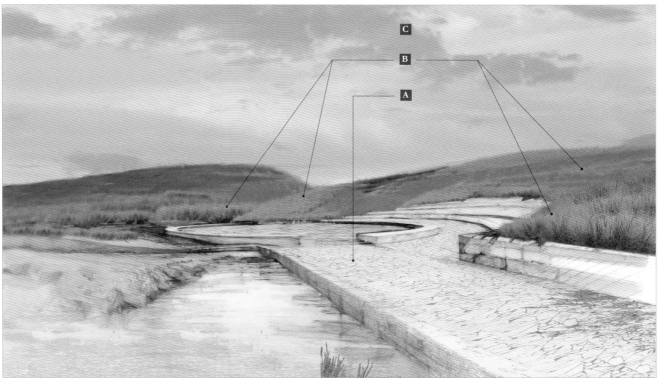

FIG 3-71. Applying materials in digital, the third step of visualization
Westmoor Park, First Place National Design Competition, CT, USA. Mixed media (collage of freehand drawing and digital media), 11 x 17 in
Illustrated by Shima Rabiee, Copyright to Balsley Balsley Kuhl

sharper, clearer and coarser and have more contrast, a more distinct texture and more details. This policy contributes to the sense of depth in the space. To better understand the rules of distance in illustration, refer to *Tone* in chapter one.

C. The color of the sky or the background color makes the image more homogenous, more beautiful and more sensible.

Note that in this rendering, we have decided to allow some touches of freehand drawing to remain visible. The seat walls in the center of the image, the side wall which is at the image's foreground, the edge of the path, and the flowing water have remained in the image in their original freehand state.

Here, the question might be brought up: now that we are going to cover a vast area of the image with digital elements and materials, why begin drawing with the freehand in the first place? The answer is: the back layer of the image which was done with freehand (and with the same purpose as underpainting in painting), plays a significant role in controlling values and harmony, homogenizing the image and creating a desired dynamic and sense of space in the image. The dynamic and mood of the space is determined by the colors harmony, values, contrasts and the extent of details and realness or unrealness of objects. Had we started drawing this image with digital elements and tools from scratch, we would not have reached this result. In that case, the mood and dynamic of the space would be different, because the colors would be more intense and the objects sharper. This would make the space seem more real and would give it a different kind of dynamic.

Note the following points which are vital in the freehand-digital technique:
• Generally, working with freehand controls the dynamic and mood of space and to some extent prevents the space from being too real. Depending on the target, subject and phase of the design we are in, this is sometimes very desirable. Hence, if the mood and dynamic of space are important for us and are among the characteristic factors of the design, the medium of visualizing the space is also important and should be chosen with great care.

• Note that in this image, it is not easy to distinguish freehand from digital elements/texture. This is one characteristic of using freehand drawing as underpainting: in this case, we do not need to digitalize all planes and come up with a complete and homogenous image. Freehand drawing controls the general color and harmony of the image and at the same time it does not force us to perceive and present the details of all parts of the image in a realistic manner.

• Note that any digital element which is combined or collaged with freehand perspective, should possess the same perspective properties as those of the freehand drawing. Its viewpoint, vanishing points and horizon line should match those of the freehand drawing, so that together they present a unified, homogenous and real space and they do not confuse the viewer.

***To learn more about this step of visualization, refer to the following discussions:*
- Internal form (Chapter 1), Color (Chapter 2), and Technique I: Digital-Digital, Step 3 (Chapter 3).

STEP 4: CREATING HARMONY AND SENSE OF UNITY

In order to achieve balance, homogeneity and unity in the harmony of image, as demonstrated in *Figure 3-72,* we should do the following:

- **Creating balance and unity in the image's visual weight and extent of details:**

Here, we examine the extent and density of the plants and the details applied, in order to make sure that they are homogenous in the entire image and the images has a balanced visual weight.

- **Reducing gaze and variety in the colors' dimension and temperature:**

Here, we level the harmony of colors, as explained in previous chapter and example one of this chapter.

*"**To learn more about this step of visualization, refer to the following discussions:*
- Color and Harmony (Chapter 2),
- Technique I: Digital-Digital, Step 4: Creating harmony and sense of unity (Chapter 3).

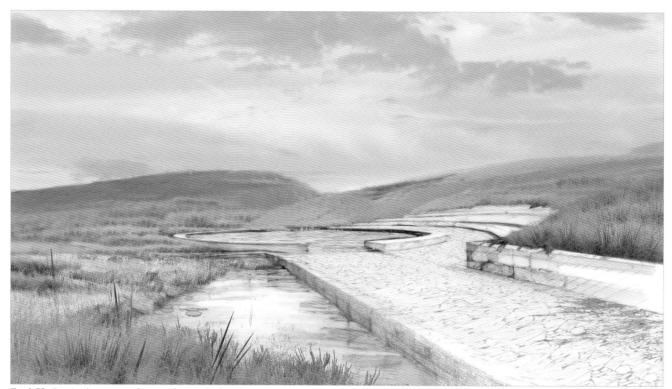

FIG 3-72. Creating harmony and sense of unity, the fourth step of visualization
Westmoor Park, First Place National Design Competition, CT, USA. Mixed media (collage of freehand drawing and digital media), 11 x 17 in
Illustrated by Shima Rabiee, Copyright to Balsley Balsley Kuhl

STEP 5: REVEALING THE THREE-DIMENSIONAL FORM

THROUGH IMPLICATION OF LIGHT AND SHADOW

At this stage, we follow the below step:

• **Applying the light and shadow to the objects in the space:**

Here we apply light and shadow to the volumes, while considering the followings *(Figure 3-73):*

- Increasing the extent of shadow to express the form better and enhance the composition.

- Increasing the contrast and intensity of light and shadow to communicate the three-dimensional form and focal point better in the image.

***To learn more about this step of visualization, refer to the following discussions:*
- Tone (Chapter 1),
- Contrast, Focal point, and Visual weight and movement(Chapter 2),
- Technique I: Digital-Digital, Step 5: Revealing the three-dimensional form (Chapter 3).

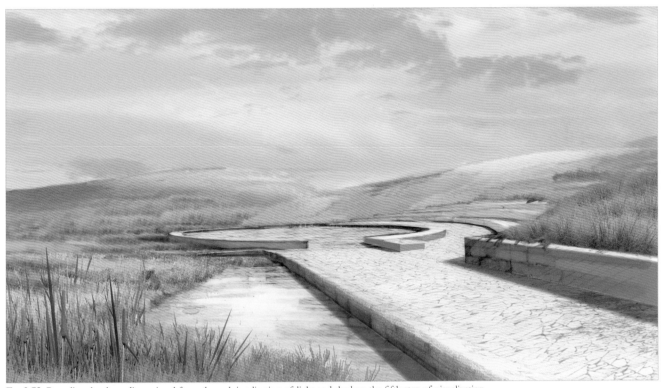

FIG 3-73. Revealing the three-dimensional form through implication of light and shadow, the fifth step of visualization
Westmoor Park, First Place National Design Competition, CT, USA. Mixed media (collage of freehand drawing and digital media), 11 x 17 in
Illustrated by Shima Rabiee, Copyright to Balsley Balsley Kuhl

STEP 6: EXPRESSING DEPTH AND SPATIAL QUALITY

In this step, for further expression of depth, we consider the followings *(Figure 3-74)*:
- **Choosing and repeating similar elements in different scales:**

In this example tree trunks, shrubs of similar type, and human figures are used as three repetitive elements in order to create a sense of depth. Note that to create an effective illusion of depth, these elements have been used in all three planes of the image, in the foreground, midground and background, with three different scales.
- **Gradually changing the value of similar elements on the page:**

Here, the sharpness and darkness-lightness of all the elements are gradually reduced as they move from the foreground towards the background. As you can see, the figures in the background of the image are fainter, less sharp and with less detail as those in the foreground.

***To learn more about this step of visualization, refer to the following discussions:*
- Tone (Chapter 1),
- Illusion of depth, Grouping and directions (Chapter 2),
- Technique I: Digital-Digital, Step 6: Expressing depth and spatial quality (Chapter 3).

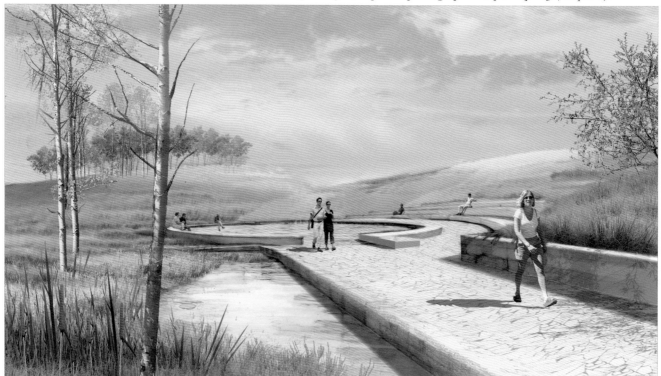

FIG 3-74. Expressing depth and spatial quality, the sixth step of visualization
Westmoor Park, First Place National Design Competition, CT, USA. Mixed media (collage of freehand drawing and digital media), 11 x 17 in
Illustrated by Shima Rabiee, Copyright to Balsley Balsley Kuhl

STEP 7: ENHANCING THE COMPOSITIONAL STRUCTURE

At this stage, we follow the below step:

- **Adding the design elements that complement the space while enhancing the composition and focal point** *(Figure 3-75)*:

At this stage, we add the remaining elements which we would like to show in the image. Note that, as discussed in the first example, the necessity of separating this stage from the previous one lies in gaining more control over the image's composition and visual elements. If we insert all elements simultaneously, reaching the ideal composition would become very difficult. This is like *seeing from the big picture to the detail* in art, which means that the drawing is made in multiple stages and each stage should appear complete in it's own way. The further stages are simply applied to make it richer, more real, and comprehensible.

***To learn more about this step of visualization, refer to the following discussions:*
- Tone (Chapter 1),
- Illusion of depth, Visual weight and movement, Harmony, Focal point (Chapter 2),
-Technique I: Digital-Digital, Step 7: Enhancing the compositional structure (Chapter 3).

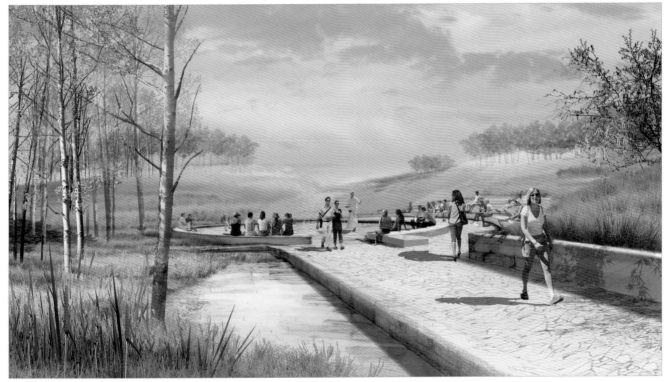

FIG 3-75. Enhancing the compositional structure, the seventh step of visualization
Westmoor Park, First Place National Design Competition, CT, USA. Mixed media (collage of freehand drawing and digital media), 11 x 17 in
Illustrated by Shima Rabiee, Copyright to Balsley Balsley Kuhl

STEP 8: CREATING DYNAMICS, MOVEMENT, AND ENERGY

In this stage we offer the viewer a stronger sense of movement and energy present in the illustrated space, by some or all following methods *(Figure 3-76)*:

• **Demonstrating movement:**

Here, the movement of the birds in the background, that of the humans in the foreground and the performance in the midground—all of which contain a sense of movement and dynamism—offer an example of this method.

• **Demonstrating reflections:**

For example, the reflection of the environment in the water could be a part of this method and, if attended to with more details, it could have turned into the image's center of attention. The waves on the water surface or the reflection of the environment in it can make the space appear livelier.

• **Applying filters and effects for the sake of composition, movement, and presentation:**

In this example, the darkness and lightness at the edges of the image—which are not part of the image, but rather an external filter—can move the eye across the image and add to the image's dynamism and the beauty of its composition.

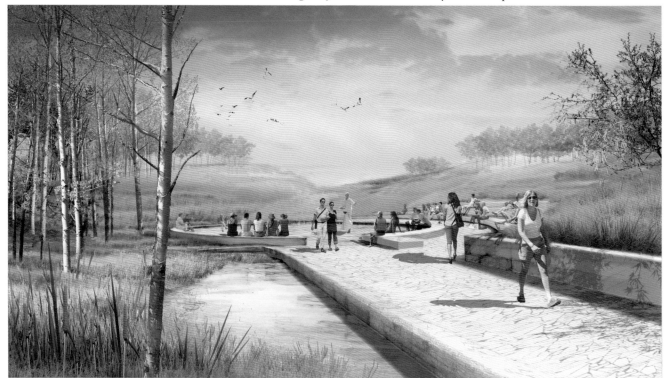

FIG 3-76. Creating dynamics, movement, and energy, the eighth step of visualization
Westmoor Park, First Place National Design Competition, CT, USA. Mixed media (collage of freehand drawing and digital media), 11 x 17 in
Illustrated by Shima Rabiee, Copyright to Balsley Balsley Kuhl

***To learn more about this step of visualization, refer to the following discussions:*
- Tone (Chapter 1),
- Visual weight and movement (Chapter 2),
- Technique 1: Digital-Digital, Step 8: Creating dynamics, movement, and energy (Chapter 3).

CONCLUSION

In the process of learning any new subject, learning the basics and fundamentals is most important. The basis of visualization is understanding the basic principles of art. Principles of art help us connect to the audience's thoughts and emotions and communicate our design intent to them more quickly and expressively.

In this book, we deliberately introduced the principles of art in the first two chapters and brought examples for each of these principles from the viewpoints of the world's great historical and contemporary artists. We studied the composition through *Franz Kline's* and *Giovanni Domenico Tiepolo's* drawings. We introduced the tone and its uses in creating depth and three-dimensional illusion with *Georges Seurat's*, *Mu Ch'i's*, *Eugène Delacroix's*, and *Gaetano Gandolfi's* drawings and its use in expressing the form with *Rembrandt's* and *Zhaoming Wu's* drawings. We also analyzed different types of form from the viewpoints of *Josef Albers*, and *Harold Tovish*. The influence of the line type on the mood of space was analyzed by drawings of *Oskar Kokoschka*, *Henri Matisse*, *Alberto Giacometti*, *Paul Cezanne*, *Henri Gaudier-Brzeska*, *John B. Flannagan*, *Eugène Delacroix*, and *Georges Seurat*, etc. During this study, we both got to know the opinions of masters of art about the concepts and the implications of the fundamentals of art, and also the techniques they have used in their works in order to control the viewer's gaze and feeling. For example, we saw how they have used repeating elements to guide the viewer's look across the page, or how they have avoided uniform visual weights in order to create a dynamic and energetic image, and so on.

In the first and second chapters of the book, we used these principles of art in the process of visualizing design, in the same way as the art masters have, and brought examples for each one of these principles. For example, how tone can contribute to the three-dimensional sense of plan, elevation and perspective drawings; or how the choice of colors can facilitate understanding the depth and three-dimensional form of the space; or how the composition, positive and negative spaces, etc. can play a significant role in making the visualization more expressive and legible. We explained the role and impact of basic concepts and principles of art in visualization in text and images.

In the third chapter of the book we demonstrated in three examples, how it is possible to use these principles in the visualization process with images and step-by-step explanation. As a conclusion in this chapter, we precisely and concisely introduced the eight stages of visualization which cover all the art principles applicable to design visualization. We also emphasized that using these fundamental stages in visualization makes it more effective, beautiful, and comprehensible regardless of its technique. Then we brought three examples with the freehand, mixed-media, and digital techniques and introduced the implementation of these stages step-by-step with textual and visual explanation.

In the final section of the book, we included further examples which emphasize the fact that if we are familiar with principles of art, we can visualize the design in a beautiful, effective and expressive way regardless of the visualization technique. Therefore, at the end of this book I suggest that in order to improve and further learn visualization, you invest enough time and energy in deepening your knowledge of the principles of art besides learning the latest techniques and tools of visualization. You will clearly witness the impact of this education in the design process, visualization, and representation of your designs.

SAMPLE ILLUSTRATIONS

SAMPLE ILLUSTRATIONS (TECHNIQUE I: DIGITAL-DIGITAL)

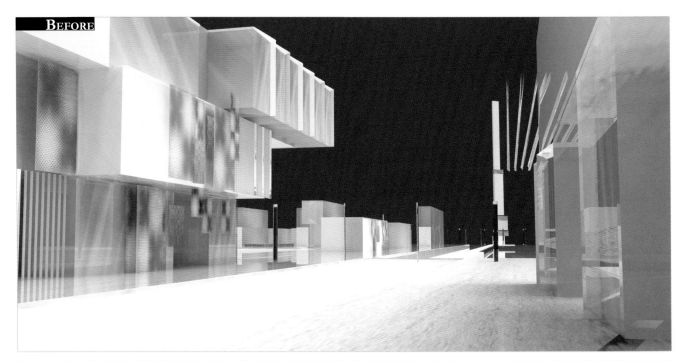

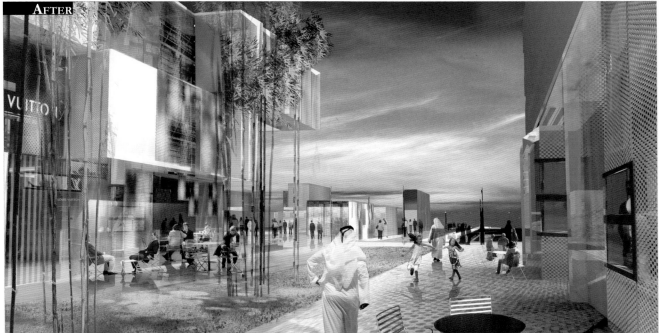

FIG 4-1. Culture Village Waterfront Development (phase two), Dubai, UAE. Digital media, 17 x 24 in. Illustrated by Shima Rabiee, Copyright to SWA Group

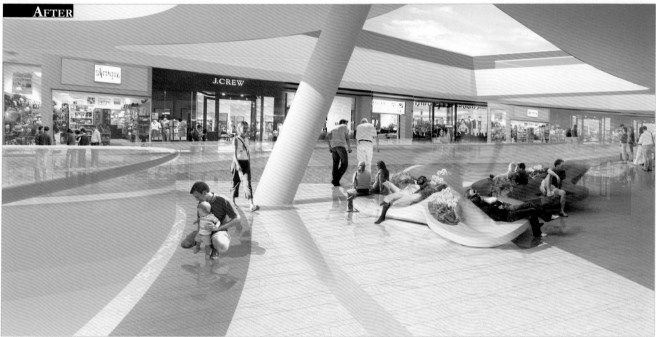

Fig 4-2. North Bund White Magnolia Plaza, Shanghai, China. Digital media, 11 x 17 in. Illustration by Shima Rabiee, Copyright to SWA Group

BEFORE

AFTER

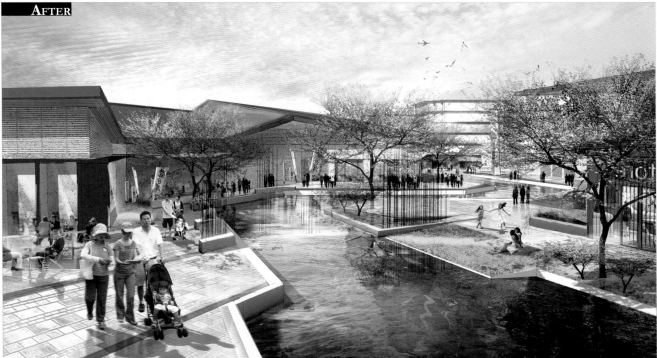

FIG 4-3. Hefei Tangchi Planning (Tourism Conceptual Masterplan), Hefei, China. Digital media, 11 x 17 in. Illustrated by Shima Rabiee, Copyright to SWA Group

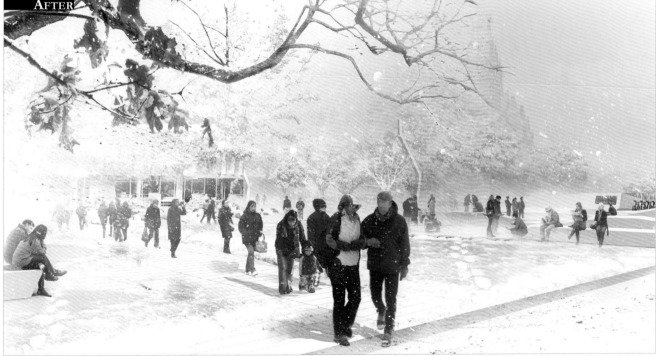

FIG 4-4. The Plaza at Harvard University, MA, USA. Digital media, 11 x 17 in. Illustrated by Shima Rabiee, Copyright to Stoss Landscape Urbanism

SAMPLE ILLUSTRATIONS (TECHNIQUE II: MIXED MEDIA)

EXISTING SITE PHOTO IMAGE + DIGITAL MEDIA

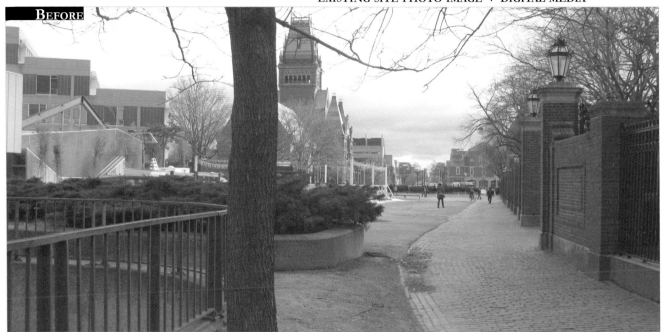

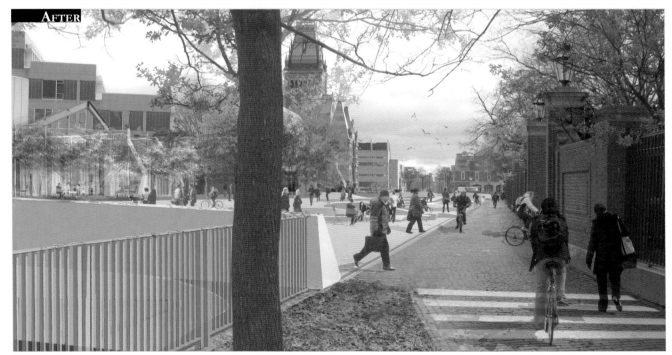

FIG 4-5. The Plaza at Harvard University, MA, USA. Digital media, 11 x 17 in. Illustrated by Shima Rabiee, Copyright to Stoss Landscape Urbanism

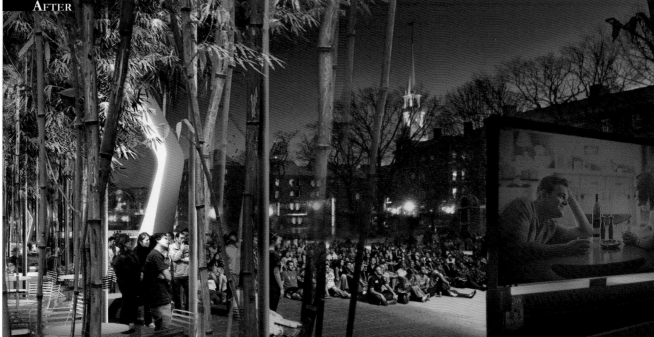

Fig 4-6. The Plaza at Harvard University, MA, USA. Digital media, 11 x 17 in. Illustrated by Shima Rabiee, Copyright to Stoss Landscape Urbanism

FIG 4-7. Allen Parkway Landscape Enhancement, Texas, USA. Digital media, 11 x 17 in. Illustrated by Shima Rabiee, Copyright to SWA Group

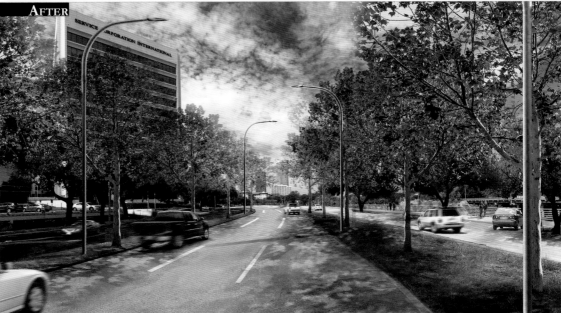

Fig 4-8. Allen Parkway Landscape Enhancement, Texas, USA. Digital media, 11 x 17 in. Illustrated by Shima Rabiee, Copyright to SWA Group

SAMPLE ILLUSTRATIONS (TECHNIQUE III: FREEHAND-DIGITAL)

STEP 1

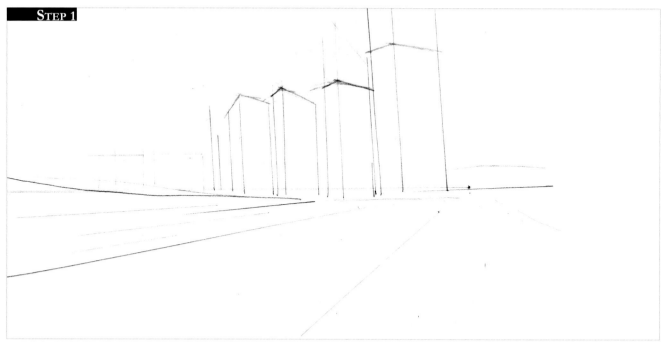

STEP 2

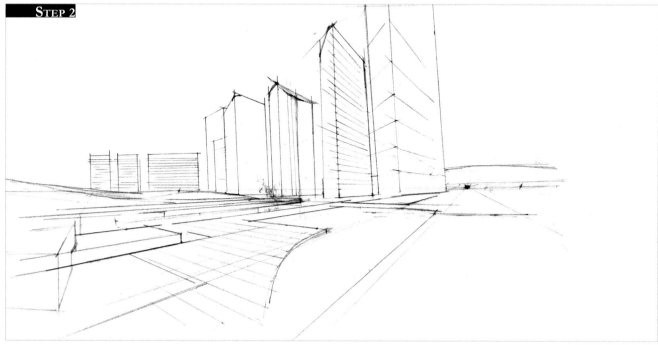

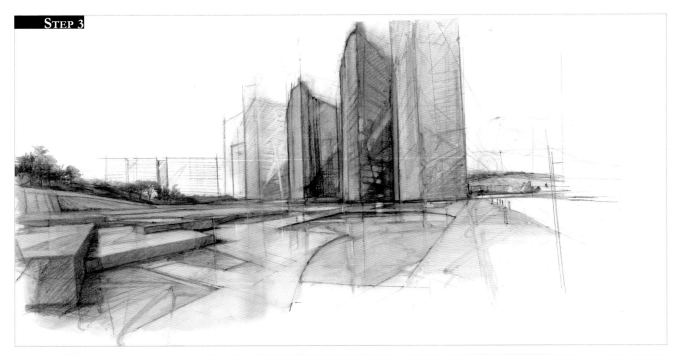

STEP 3

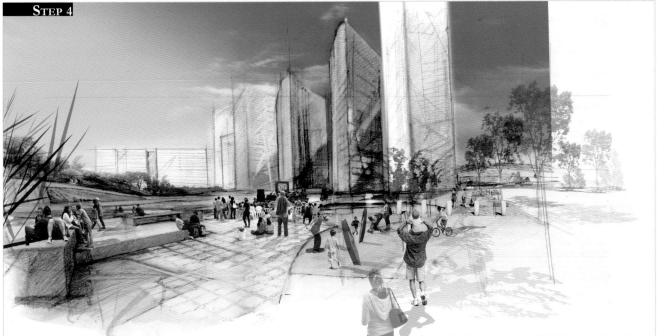

STEP 4

FIG 4-9. Operation Chamartin, Madrid, Spain. (Studio project at PennDesign, University of Pennsylvania). Digital media, 11 x 17 in. Illustrated by Shima Rabiee

STEP 1

STEP 2

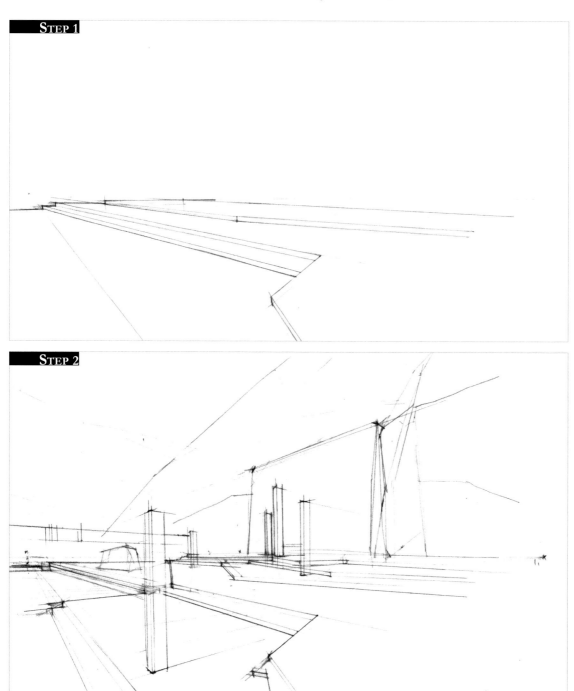

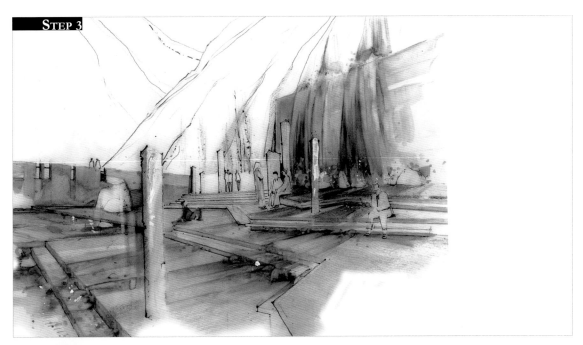

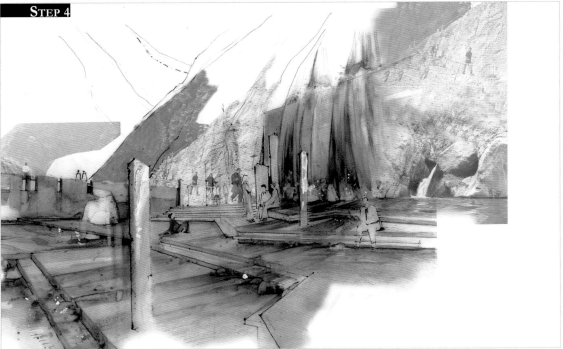

FIG 4-10. Darakeh, Tehran. (Design studio). Mixed media, 11 x 17 in. Illustrated by Shima Rabiee

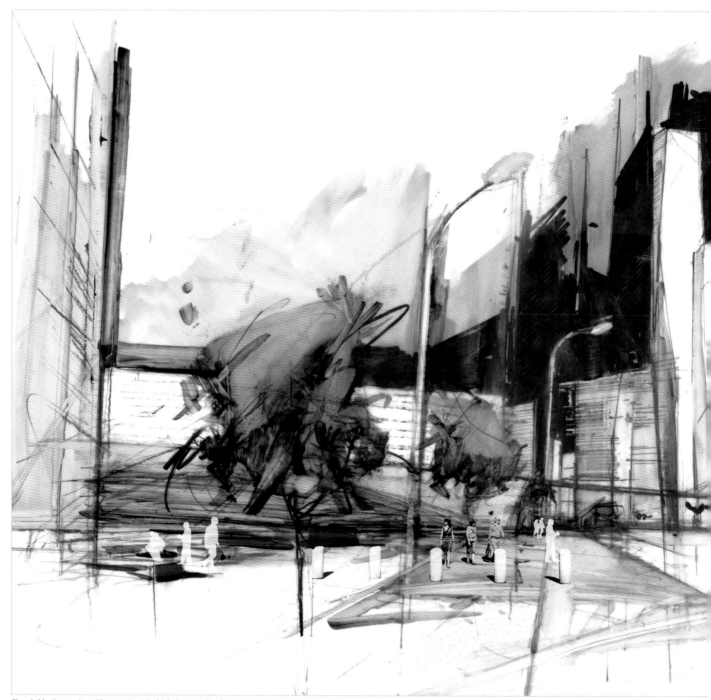

Fig 4-11. Operation Chamartin, Madrid, Spain. (Studio project at PennDesign, University of Pennsylvania). Digital media, 11 x 17 in. Illustrated by Shima Rabiee

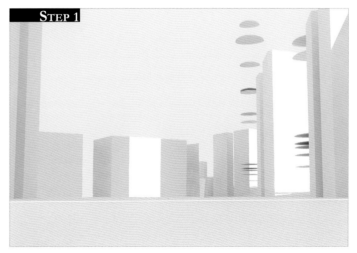

STEP 1

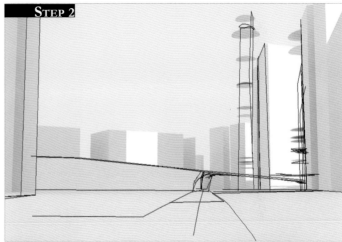

STEP 2

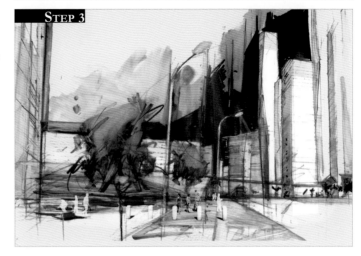

STEP 3